CARO

Photographed by John Riddy · Text by Karen Wilkin · Edited by Ian Barker

Prestel

There are many different ways of looking at the sculpture of Anthony Caro. In this book we have chosen eight of the key themes that have occupied his work from the early 1960s to date. These themes should not be regarded as exclusive categories – rather they are intended to lead the reader into a principal concern that each sculpture addresses. We have attempted neither a comprehensive survey of Caro's work nor to illustrate solely masterpieces; instead we have provided an approach which the reader can utilise as a guide to appreciating different aspects of the sculptor's oeuvre.

CONTENTS

ANTHONY CARO

EVEN TO the casual observer, it must be clear that Anthony Caro is a force to be reckoned with, perhaps *the* force to be reckoned with, in present-day sculpture. 'Caro sets a standard for us,' a younger sculptor said recently. 'He's the one we all have to get past.' For thirty years, Caro has been the pre-eminent exponent of a kind of constructed sculpture, both wholly his own and firmly rooted in the history of modernism. It has its origins in Cubist collage, by way of the unprecedented works in welded iron and steel made by Pablo Picasso and Julio González, in the late 1920s, and the innovations of David Smith, in the 1950s and early 1960s. Caro's work, like that of his modernist predecessors, denies that 'sculpture' is synonymous with 'statue'; his is not an art of carving or modelling solid forms, but of assembling discrete, often disparate parts to make new kinds of expressive objects.

Since the early 1960s, when Caro's strength first became apparent, he has been regarded as the principal heir to this 'new tradition', and praised, too, for enlarging his legacy by adapting it to a new, entirely personal abstract idiom. His sculptures look like nothing but themselves, but they are not arbitrary inventions. Profoundly based in experience, these wordless carriers of emotion speak to us as music does, as pure disembodied feeling. Since the mid-1970s, it has been increasingly clear that Caro's dialogue is not only with his modernist ancestors, but with the whole history of sculpture, with painting, and lately, with architecture. It is increasingly evident, too, that he finds intense stimulation outside of his own culture and – occasionally – outside the realm of high art. He has remained faithful to a modernist conception of constructed, collaged sculpture, but, in recent years, he has begun to challenge some of the fundamental assumptions of this idiom, by examining new ways of using materials and new notions of density, scale,

and mass, and by rethinking new possibilities of the role of sculpture itself. Yet at the same time, there are strong family resemblances between even the most diverse sculptures, recurrent themes that cut across time, and persist through changes of scale, medium, and approach; no less important than the abundant evidence of growth and change, these constants are the hallmarks of Caro's personality.

Caro announced his originality in the early 1960s when he began to exhibit eccentric and, as it turns out, unforgettable steel sculptures made by welding and bolting together industrial members: works, such as the glowing yellow *Midday* (32), at once brutal and elegant, dextrous and clumsy. *Midday* stands alertly, reaching across space, its poised, vertical I-beams signalling for attention and its rows of bolts simultaneously testifying to the history of its making and forming a delicate contrapuntal drawing. The sculpture, devoid of base or pedestal, occupies our own space, but it easily separates itself from the ordinary objects that surround us by its *otherness*,

by its insistent presence. While the industrial antecedents of its materials and method of construction are obvious, they seem less important than the force of its feeling: emotion shaped in purely sculptural terms.

Despite the many shifts and alterations along the way, the characteristics that made *Midday* and its fellows so remarkable when they were first seen have been true of virtually all of Caro's sculpture since. Typically, a Caro sculpture stamps itself out as a singular, unignorable object, but reads, at the same time, as an assembly of parts whose relationship is both logical and elusive, difficult to describe, but visually lucid. Much of the eloquence of Caro's work resides in the way elements are placed, in the intervals between them, in how things touch, back off, and angle away from one another, in how they respond to gravity and resist it. The American philosopher and critic, Michael Fried, London correspondent of *Arts* magazine when Caro made works such as *Midday* and, like Clement Greenberg, an early champion of these sculptures, was one of the first to point out how much they depended on this kind of 'syntax', as he called it.

Works like *Midday* were, in some respects, as new to Caro as they were to their first viewers. After gaining an engineering degree at Cambridge, he had been a prize-winning student at the conservative Royal Academy Schools, in London. There he met and married Sheila Girling, the painter whose exacting eye has contributed much to his sculpture over the years. Wanting to broaden his art education, the 27-year-old novice presented himself at Henry Moore's studio – 'He was the best modern sculptor in England,' Caro explains – and remained as Moore's assistant from 1951 to 1953. Caro speaks warmly of

Moore, of his generosity, of the importance of his example; Moore's library, with books on African sculpture, Surrealism, and much more that the Academy's traditional curriculum had ignored, affected him deeply, as well.

By the mid-1950s, Caro was modelling thickset nudes in clay or plaster, for casting in bronze. He has described these figures, which rest heavily on the ground or struggle to rise, as being about 'what it is like to be inside the body', a condition, for him, of being oppressed by gravity. They earned the young sculptor places in several prestigious exhibitions and a purchase by the Tate Gallery, but in spite of such evident approval, Caro was dissatisfied. He was already making efforts to alter his approach when the American critic, Clement Greenberg, visited his London studio for the first time, in the summer of 1959. However, real change did not occur until later that year, after his first trip to the United States, sponsored by the Ford Foundation.

In the United States, Caro visited museums, galleries and studios across the country, saw Greenberg in New York and met the artists Kenneth Noland, Helen Frankenthaler, Adolph Gottlieb and David Smith, among others. The Americans' energy and adventurousness fascinated Caro, as did their uninhibited attitude toward materials and methods. Caro recalls that it was Greenberg who summed up the lesson of the experience: 'He said if you want to change your art, change your methods'.

When he returned to London, Caro did just that, tackling for the first time scrap metal, girders, and found objects, unyielding but flexible new materials that were the antithesis of the malleable, responsive clay and plaster of his past. They both forced and allowed him to discover new ways of describing and

inventing form, as well as new ways of encapsulating feeling. They allowed him, as he put it, 'to make sculpture real'.

As the 1960s progressed, Caro tested the limits of his new language and his new materials. After working with bulky industrial members, he began to explore steel's ability to be both thin and strong, in vigorous, drawing-like structures. In works such as the masterly *Orangerie* (51) of 1969, or *Sunfeast* (75) of 1969-70, he used the animated twists of ploughshares and the swelling curves of tank ends to 'draw' simultaneously with edge and plane. Caro's sculptures, at this time, became increasingly 'open' – available to visual penetration – so much so that works such as *The Window* (100,101), 1966-67, depend on transparent grids, ephemeral planes whose density varies as the viewer moves. Distance, interval, the space between and within elements became more and more important.

Most of Caro's sculpture of the 1960s developed horizontally, resting on the floor of our own space, although the word 'resting' is misleading, since the law of gravity seems to have been abolished in these works. While Caro's first steel pieces appeared to rise with some effort, as his early bronze figures did – although they were not in any way *like* figures – his subsequent works seem weightless. It is as if abstraction carried with it the freedom to invent not only new kinds of objects, but new physical laws, totally unlike those that constrain our earthbound bodies.

The bright, uniform colours that Caro chose for these sculptures helped to cancel out some of the industrial associations of his beams and girders. Colour unified the variety of collaged elements and, at the same time, made the steel appear less substantial. Nonetheless, a girder, no matter what its colour, is still a large, heavy length of metal. It is not colour, but *placement*, from the simple fact of Caro's having removed a structural beam from its usual context, to the subtle internal syntax of the sculpture, that makes us willing to believe that the delicately poised steel planes and bars could float. In many of Caro's best works of the 1960s, real structural logic is irrelevant. Just as the flying buttresses of a Gothic cathedral always appear to spring upwards, no matter how much we know about the transfer of loads, Caro's works of this period seem to hover above the ground, restating the ground plane in terms of a new kind of physics. Structural members often seem minimal, just enough to keep the sculpture together, and interchangeable with elements that have no visible supporting function, so that key portions of the sculpture seem to levitate. Surprisingly, other works of these years hug the ground, notably the pared-down pieces (1,7) made between 1963 and 1965, when Caro taught at Bennington College, in Vermont. As if providing an antidote for the sleight of eye of works like *Month of May* (18) of 1963, the Bennington pieces crawl along, measuring the distance travelled in a series of punctuating angles and staccato turns.

Traditional sculpture – statues – usually alluded to the upright human figure and described it in terms of solid forms. In the 1920s and 1930s, Picasso and González made it possible for open, thin-walled volumes constructed in iron and steel to be called 'sculpture' and for objects that looked like nothing pre-existing to convey emotion. But they continued to refer to the body, in their pioneering heads and figures. David Smith appropriated the vocabulary of the industrial vernacular for his sculptures of the

1950s and 1960s, but while his tripod and wheel-mounted structures were less explicitly about the body than Picasso's or González's, something decidedly animated, confrontational and, well, *figure-like* remained. Caro, once he began to work in steel, not only avoided solid forms and masses, but scrupulously avoided any allusion, however remote, to the figure. Since we tend to anthropomorphise anything vertical, perhaps because it carries with it a memory of our own upright posture, Caro avoided verticality in these early years. There is the occasional exception, but sculptures of this type are so attenuated, like the grounded Bennington sculptures, that figuration is not an issue; they are like lines drawn in the air, sculptural equivalents of the Indian rope trick (6).

The way Moore's boulder-like reclining figures, which Caro knew intimately, stretch along the ground makes comparison tempting, but Caro's conception of what sculpture could be is wholly opposed to Moore's. Caro's structures are, in his word, 'real'; as compelling as anything in the existing world, they look like nothing we already know. Their size and the space they occupy are literal. Moore's mature work is largely metaphorical, reminding us how landscape forms (among other things) echo the forms of the body; scale and space shift between actuality and illusion. For Caro, horizontality is not an equivalent for reclining, but an end in itself and a kind of guarantee of abstractness. Horizontality, like Jackson Pollock's placing his canvases on the floor to paint them, gave Caro a new freedom of construction. A sculpture could be expanded and extended at the artist's pleasure, its structure dictated neither by the logic of the human body nor the perennial bugbear of support. Smith often began his sculptures on the ground, for similar reasons, but he hauled them into a vertical position to complete them, while Caro's 'ground-flung' sculptures, as they have eloquently been described, prolong process, making it an end as well as a means. We recapitulate this process because we perceive these horizontal sculptures from the same vantage point as their maker did, from all sides, even though there is almost always a strong sense of front and back in Caro's sculptures.

At the same time, these pieces demand to be viewed from specific points. Although they often spread accommodatingly at our feet (or, recently, seem to embrace us) the sculptures themselves determine the distance from which they must be viewed, because of their size or the placement of parts; elements can serve as barriers, keeping us at bay. Caro's works arrest the viewer at fixed points, so that we move around them in fits and starts. It comes as no surprise to learn that Caro dislikes sculptures that allow the eye to slide endlessly across surfaces and around forms. He prizes works that are clearly articulated spatially and has written perceptively about this aspect of Donatello. His own best work often seems conceived as a series of tableaux, as though we were seeing a sequence of self-contained 'pictures' in a disjunctive rhythm created, paradoxically, not by pictorial effects, but by the dominance of edges, planes and profiles that cut into space.

By the end of the 1960s, Caro's sculpture was admired and acclaimed. His work had been shown in major centres in Britain, Europe and the United States. In 1969, he represented Britain at the São Paulo Bienal, while the Arts Council mounted his first important retrospective exhibition at the Hayward Gallery, London. If Caro's work had remained unchanged, his place in the history of

contemporary sculpture would still have been assured, but what followed, in the 1970s and 1980s, was, if anything, more adventurous – and more passionate – than what preceded it. There was continuity, of course. Caro continued to think of sculpture as a way of making physical and emotional experience visible and the formal means he found for embodying these concerns remained consistent. Severe geometric works of the early 1970s, such as the Silk Road series (5,12) or *Ordnance* (63), with their incremental progressions, their near-symmetry and unexpected deviations from regularity, were logical, crisper variations on the concerns of the Bennington pieces. Caro's small-scale sculptures of the period, too, continued to explore notions first stated by their predecessors in the 1960s of just what putting things on a table could mean. But there were also the thirty-seven large steel York Sculptures, made outside Toronto, Canada, during the spring and summer of 1974. They seemed startlingly new when they were made and now seem to prefigure many of Caro's recent concerns.

Until Caro began to work on the York Sculptures (8, 10, 11, 13), his improvisatory way of working eliminated the possibility of making very large sculptures or, at least, of using elements over a certain size. Since making a scale model and having it enlarged was anathema to him, his sculptures remained human in scale, made of elements that one man (or one with a little help) could manoeuvre. In Toronto, for the first time, Caro had men and equipment at his disposal that allowed him to work with a new lexicon of elements. 'The extraordinary weight of those slabs, those pieces which were unlike anything I'd handled up to then,' Caro marvelled. Some of the York Sculptures, he says, had to do with his excitement at seeing huge sheets of steel slung up and lifted as easily as he himself could move an average-size plate of metal.

Many of the York Sculptures are about this kind of surprising encounter. Others are slabs leaning on each other in seemingly spontaneous, unstable configurations, while still others are horizontal spills of metal. The large sheets are presented apparently unmodified, unpainted, as if Caro had finally succumbed to the physical properties of his chosen material, after years of dissembling, of exploiting steel's practical virtues and tensile strengths, but not its surface, substance, or weight. In the York Sculptures, Caro appears to have fallen in love with the soft-edged expanses of metal, with their exquisitely inflected surfaces and unpredictably curved edges. The act of placing these objects in unexpected positions or in the subtlest, most haphazard of relationships with other pieces of steel was almost enough to make a sculpture.

It wasn't the first time Caro used large pieces of unpainted steel, nor was it his first venture out of the studio into the factory. Smaller versions of the York Sculptures' plates and crop – the ends of a rolling mill's run – figured in the Veduggio series, made in 1972 in a small Italian steel works. The elegantly-shaped sheets of the Veduggio sculptures are often presented vertically, as though displayed on an easel. Their uprightness alters our relationship to them from one of observation to one of confrontation, but there is no memory of the body inherent in their verticality. Rather, they recall inanimate objects: paintings, gateways, mirrors and the like. The sheer size of the York Sculptures suggests architecture, rather than domestic objects, but once again, placement and the articulation of part to part are

determining factors in how we perceive them. The seemingly casual arrangement of massive plates in *Double Flats* (11), for example, suggests known building conventions less than it does a miraculous suspension of natural laws. The improbability of seeing huge sheets of steel poised as they are makes us doubly aware of the piece as a unique, invented object, rather than a wall, for all its architectural scale. Its deadpan frontality is tempered by a new emphasis on volume, typical of the series; the space trapped between the sandwiched planes becomes of paramount importance. Yet there is a sense, too, of impenetrability. Some of the York pieces shelter 'secret' sculptures, tucked under overhanging planes, while others seem to conceal as much as to display themselves. In the light of Caro's recent work, this emphasis on both volume and on containment seems prophetic.

Caro's 1975 retrospective exhibition at New York's Museum of Modern Art began with *Midday* and culminated with the York Sculptures, whose generous scale and visual bulk seemed to sum up his newest direction of the time. Even his table pieces, small-scale works that began as relatively explicit, if abstract, still lifes that incorporated grips and handles, as if to reinforce their potential for being lifted, had become massive, made of large sheets of crumpled steel. In his work of the next few years, Caro pursued visual and literal density, drawing with broad brushstrokes instead of with the wiry lines of the 1960s, yet his next working trip to North America, to lead an artists' workshop in western Canada in 1977, produced a series of linear sculptures, as delicate as the York pieces were robust. Part of the slenderness of the Emma Lake series (14, 19, 20, 62) is due to the realities of transporting steel to a remote lakeside site in northern Saskatchewan, but their emphasis on line was not just an expedient response to challenging working conditions; neither was it a return to earlier concerns. The Emma sculptures may superficially recall the drawing-like works of the 1960s, but despite their thin members and open construction, they are far more volumetric than their predecessors. Where Caro once seemed to regard transparency as a purely visual phenomenon, in the Emma sculptures he made it an abstraction of mass; in them, drawing outlined forms that substituted for literal bulk.

The linear Emma pieces have a tenuous relation to a group of Picasso drawings, typical of how Caro uses a great variety of stimuli as springboards for his art. He has been fascinated by marine propellors and piled-up picnic tables as by other sculpture, by Indian sculpture, and most recently, by architecture, but up to now, Caro, like David Smith, who insisted that he 'belonged with painters', has been most provoked by painting. Sometimes the connection is rather oblique, as in *Orangerie*, whose narrow, curving shapes evoke Matisse's cut-outs without looking specifically like any of them. At other times, it is more a question of common preoccupations. The clear, linear Bennington pieces, for example, have inevitable associations with the clean-edged bars of Kenneth Noland's Chevron and Stripe paintings, made in the mid-1960s, when the two artists saw each other frequently. The cursive edges, declarative spread, and emptied-out centres of the Veduggio and York series reflect Caro's like-mindedness with his friends Helen Frankenthaler and Jules Olitski, whose paintings deal with similarly inflected expanses and articulated edges. The heightened physicality of Caro's recent work, while in some respects simply

characteristic of art of the 1980s, also speaks of his sympathy for the built-up surfaces of Olitski's and Larry Poons's recent canvases. Lately, however, Caro has paid more attention to Old and Modern Master painting than to that of his contemporaries, basing a series of complex sculptures on works by Rubens (108), Rembrandt and Manet (42, 82), translating not their imagery but their tonal contrast and bravura paint handling into sensuously curved steel.

For all the constants in Caro's sculpture, it is nevertheless difficult to discuss his work in terms of thematic progressions or serial development. The way he proceeds is complicated. He begins sculptures rapidly, more than one at a time, but he can spend years bringing them to a point that satisfies him. Each group of works feeds the next, whatever the differences between them, and he often returns later to ideas he has not yet exhausted, or reconsiders earlier notions in the light of subsequent discoveries. To keep his sculpture fresh, he often works in ways that are not habitual to him, changing his stock, the size of his sculptures, or his medium, and in the last fifteen years or so, he has repeatedly changed his place of work. His London studio remains primary, but in addition to the Italian and Canadian ventures of the 1970s, Caro has worked for extended periods in Spain, Germany, Holland, and, every summer since 1982, in the United States, where he maintains a studio and has founded an annual international artists' workshop. He remains in close contact with many younger sculptors, former students, assistants, and workshop alumni, an echo of Moore's generosity at the beginning of his own career, and possibly, a way of keeping himself off balance.

Caro's later work is most striking for its unpredictability and riskiness, as if with maturity he experienced a desire to see just how far he could go within the boundaries of his chosen territory, perhaps even a wish to go beyond that territory. Caro now permits himself many things that he deliberately banned from his earlier work, not through self-indulgence, but in a genuine effort to extend the limits of sculpture. In the past decade, he has worked in media not usually associated with modernist construction – clay, wood, paper, lead, silver and bronze – as well as 'traditional' steel, stainless steel and found objects. Each change of medium has occasioned a rethinking of formal and expressive possibilities. What has remained constant is the passionate enthusiasm for each material's physical properties that first manifested itself in the voluptuous sheets of steel of the Veduggio and York sculptures.

That Caro chose to work in bronze, a material he abandoned when he began to make abstract sculpture in 1960, is an indication of the broadening of his thinking. For him, using iron, steel and scrap metal was not the self-conscious declaration of modernism that it had been for Picasso and González, or even for Smith; steel and scrap were simply materials that allowed him to work directly and freely. He rejected bronze, despite its sensuousness and beauty, not for ideological reasons, but because it required preconception. Yet by the late 1970s, in part because of experiments with clay, Caro found himself interested in the shapes and forms that bronze permitted and attracted to its freight of art-historical associations. To reclaim this traditional material for himself, he had to devise a method of constructing directly with pre-cast shapes, brass sheets and rods; the beauty of surface and the richness of associations were transformed into his own immediate idiom.

Like traditional materials, solid forms (or dense, massive ones) often seem inextricably linked to an older, figurative tradition of sculpture, so much so that openness, in the early days of modernist construction, was a necessity – if sculptors were to avoid reminders of the organic forms of the body. Caro's massive, volumetric – and abstract – recent sculpture questions that assumption. His new appetite for mass has declared itself in tandem with an appetite for monumental scale. Many of his latest works are behemoths, not only dense, richly articulated, and intensely physical, but astonishingly large.

Some suggest that they could be entered, in contrast to his early, slightly aloof works, which were frequently praised for being accessible only to sight. Caro has been looking hard and thinking hard about architecture, from Romanesque and Renaissance churches, to Indian temples, to his own 1987 workshop collaboration with the architect, Frank Gehry, on a playful 'sculpture-village'. (After the project, the core forms of the 'village' became the genesis of monumentally scaled, building-like sculptures that, four years later, are still evolving.) A few towers and half-scale versions of loose-jointed, potentially 'habitable' works, such as *Lakeside Folly* (112) of 1988, which Caro has termed 'sculpitecture', tread a tightrope between function and invention, balancing between carpentry and art. Other recent works, such as *Elephant Palace* (106) of 1989, are like sealed enclosures, all impenetrable exterior. Caro finds nothing contradictory in his newly expanded vision. He sees himself as simply investigating areas that have been opened up by what he calls 'the broadening of sculpture'. 'Abstraction makes other things important. You sacrifice the figure and you get things that you never had before – rather, you had them but

as part of the figure, not independently – like interval or issues of scale or architecture.'

Despite this broadening, many aspects of Caro's work remain unchanged. Placement is still crucial and drawing still plays a dominant role, rather like a solo instrument whose voice carries the burden of melody above and through complex orchestration. The edges of thick planes, the slots and spaces between massive elements, seams, even the profiles of twisting sheets of steel, all function as expressive linear elements. Usually the most delicate portions of the sculptures, they substitute for non-existent thin members that would be overwhelmed by the sheer size of other components. At the same time, this surrogate drawing reinforces our sense of weight and mass, by calling attention to how the sculptures were made and shaped. But Caro has not abandoned his more usual way of drawing with delicate line. Since 1987, a series of working trips to Barcelona, whose ubiquitous ironwork and art nouveau arabesques caused Caro to describe it as 'a place all about drawing', resulted in a group of smaller-scale works. The orchestration of elegant geometry and frozen calligraphy in the Barcelona and Catalan series (26, 29-31, 45, 69) suggests doors, balconies, windows, and even the flourishes of Catalan ironwork, without looking particularly like any of those things.

Yet another group of sculptures was provoked by Caro's first trip to Greece, in 1985. He was bowled over by the pediments of the Temple of Zeus, at Olympia: the still drama of the preparations for the chariot race on the east pediment, the stylised turmoil of the battle between the Centaurs and Lapiths on the west. The monumental, but human-scale *Xanadu* (116) of 1986-88 is part of Caro's response to Olympia. Like the sculptures of more or less the

same period, based on Rembrandt, Rubens and Manet's example, *Xanadu* and its fellows translate potent figure compositions into 'sentences' of curving, volumetric units. Caro speaks of Baroque sculpture in relation to these elements, yet geometry informs them, just as it does the best of Greek figure sculpture. The Greeks seem to have begun with abstract, ideal geometric forms and to have brought them to life – in contrast to nineteenth-century academicians who smoothed the irregularity of the actual into blandness. Each phrase of *Xanadu* is active, shadowy, with a lively play of flat, convex, concave and just plain indescribable shapes that, perhaps, stand for the complexities of human form without looking like anything human.

I do not suggest that Caro has started to make disguised figure sculpture, but we experience these works in relation to our own bodies, measuring each element against ourselves. In a sense, this is nothing new. Even the most stripped-down of Caro's early works elicited this kind of response; we mentally launched ourselves across the spaces these sculptures bridged, felt uplifted by the way they floated against the ground. Caro's architecturally-scaled sculptures make this quality 'real', as well, since full understanding of the pieces depends not on sight alone, but on literally moving into and through the work.

Sculptures like *Xanadu* or the boxy *Elephant Palace* are somewhere in between: accessible only to the eye, they also pose questions about the relation of interior and exterior, containment and openness.

Caro's work of the past few years is no less abstract than the work that established his reputation, but it is more ambiguous, sometimes even allusive. Caro explains the change as an inevitable part of the expansion of modernist sculpture's possibilities. 'In the 1960s, there were forbidden areas,' he says. 'Sculpture is made of the same stuff artifacts are made of. It can so easily become inexpressive, another artifact. In the 1960s, we did everything to avoid allowing our work to look like an insect or a piece of furniture. Now abstraction is so firmly established within the language of sculpture that it no longer requires that sort of defence.'

Caro shows no signs of slackening his pace. There has been no diminution of his remarkable ability to invent objects that demand and reward our attention, puzzle us, challenge us, and stir us deeply. At a time when fashionable taste questions the very notion of excellence, the intensity, conviction, and sheer unexpectedness of Caro's best work make it speak more eloquently than ever. As that young sculptor said recently, he continues to set standards for anyone who takes sculpture seriously.

THE
GROUND

FOR CENTURIES, statues were set on plinths or raised on pedestals. The dominant horizontal ground plane of ordinary experience was, for the most part, irrelevant, an unavoidable given that had nothing to do with traditional sculpture's concerns. Even after the advent of modernism, sculptors persisted in setting their works on bases, just as painters continued to surround their pictures with frames, to reinforce the difference between actuality and the work of art.

Some inventive modernist sculptors made the base part of their original conception. Constantin Brancusi's stacked geometric bases are as adventurous as (and sometimes more so than) his sleek, streamlined carvings, although he always distinguished between his suggestive sculptures and the abstract constructions on which he placed them. Alberto Giacometti, in his early Surrealist sculpture, sometimes alluded to landscape, making the ground plane part of the sculpture, but these were small works, meant to be displayed on traditional pedestals.

Anthony Caro's first abstract sculptures dispensed entirely with any vestige of the base, by spreading boldly into the viewer's own space. He has continued to situate his works in this way, forcing them to declare their difference from other objects by virtue of their unexpectedness and their emotional charge. Caro has never regarded the ground plane merely as a necessary, unavoidable given, but sees it as an important element against which his sculptures react. The ground is never simply a support, the law of gravity notwithstanding. Caro's sculptures claim the space in which they are located, skim the ground, or defy physical laws by springing lightly away from it; they never rest heavily.

Caro dislikes the notion that horizontal spread is an equivalent for reclining, and denies that his ground-based works derive from the figure. He speaks of them in completely other terms, sometimes referring to his sculptures as 'fast' or 'slow'. Often this has to do with how works are perceived, the rhythm at which the eye moves from part to part, or the way they separate themselves from their surroundings. But it also refers to how the sculptures pace themselves across a given distance – the high-stepping, solemn progress of *Dark Motive* (5) or *End Game* (12), the low-lying syncopation of *Shaftsbury* (1), the stately hovering of *Lock* (3), the joyous upward thrust of *Wide* (9), and so on. The sculptures all acknowledge the ground plane, but they are not inhibited by it in any way. Even massive works, like *Low Line Flats* (4), or *Skimmer Flat* (8), which remain close to the ground, also strive away from it, as though subject to a weaker gravitational field than our own.

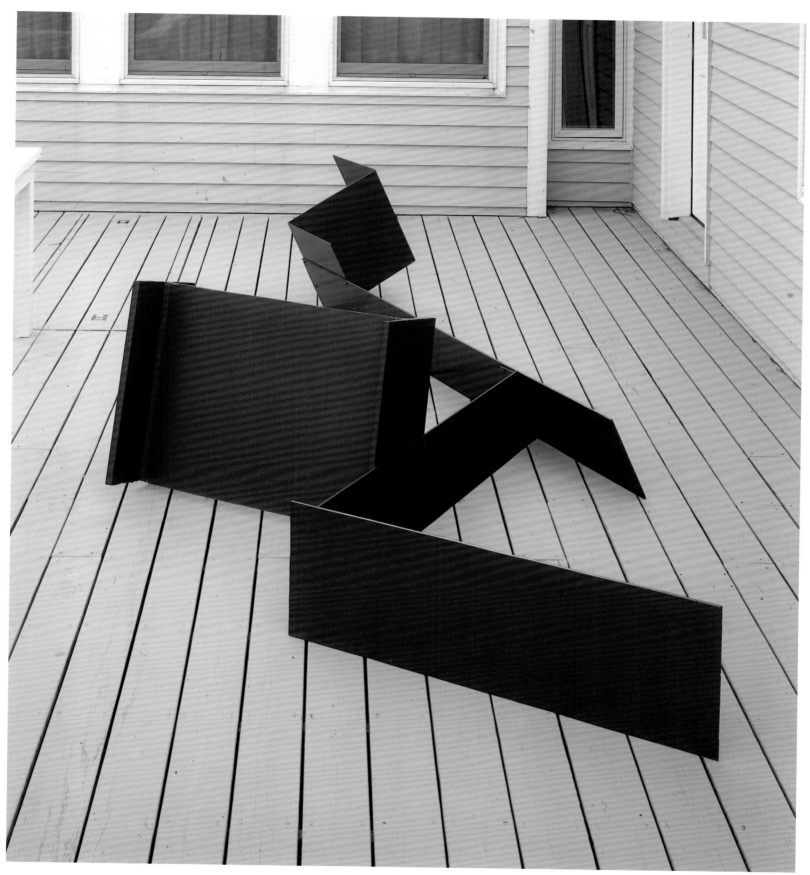

1. SHAFTSBURY 1965

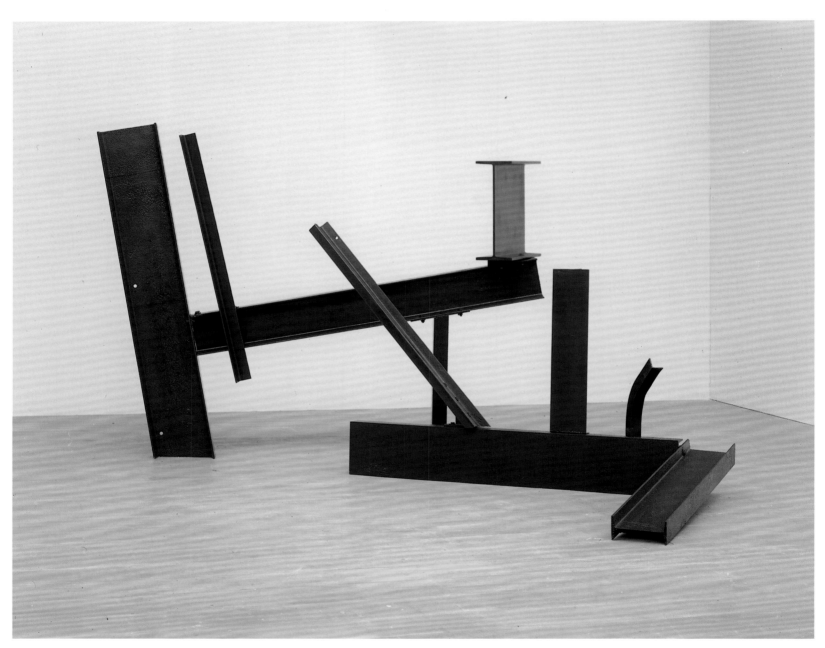

2. SCULPTURE TWO 1962

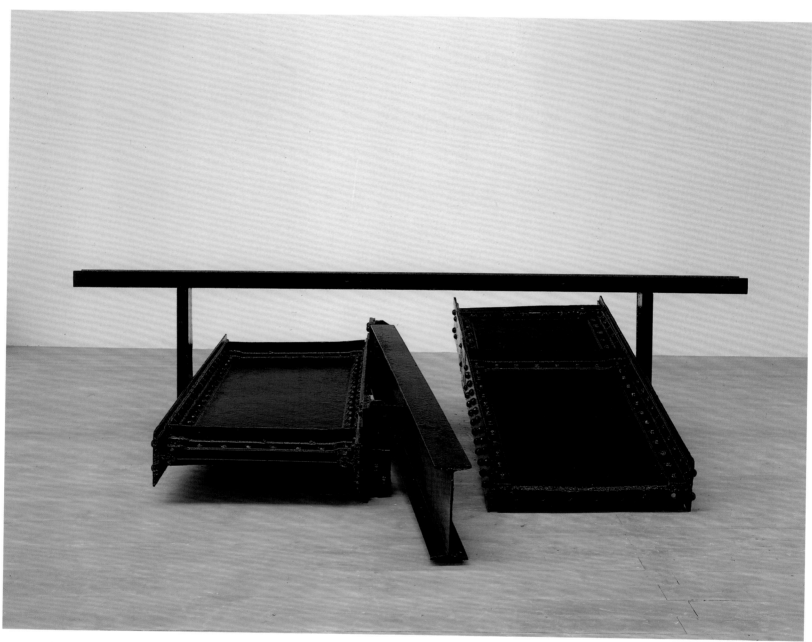

3. LOCK 1962

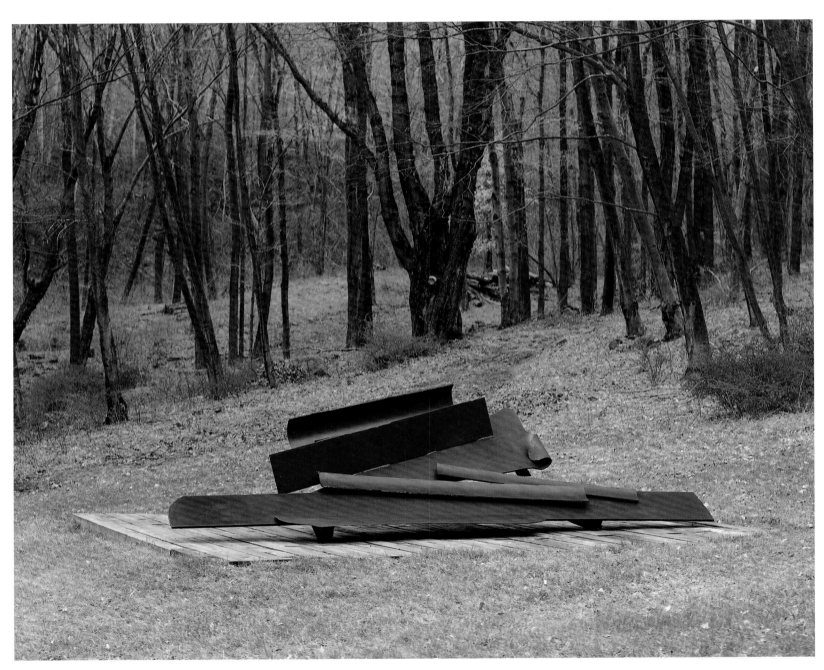

4. LOW LINE FLATS 1974

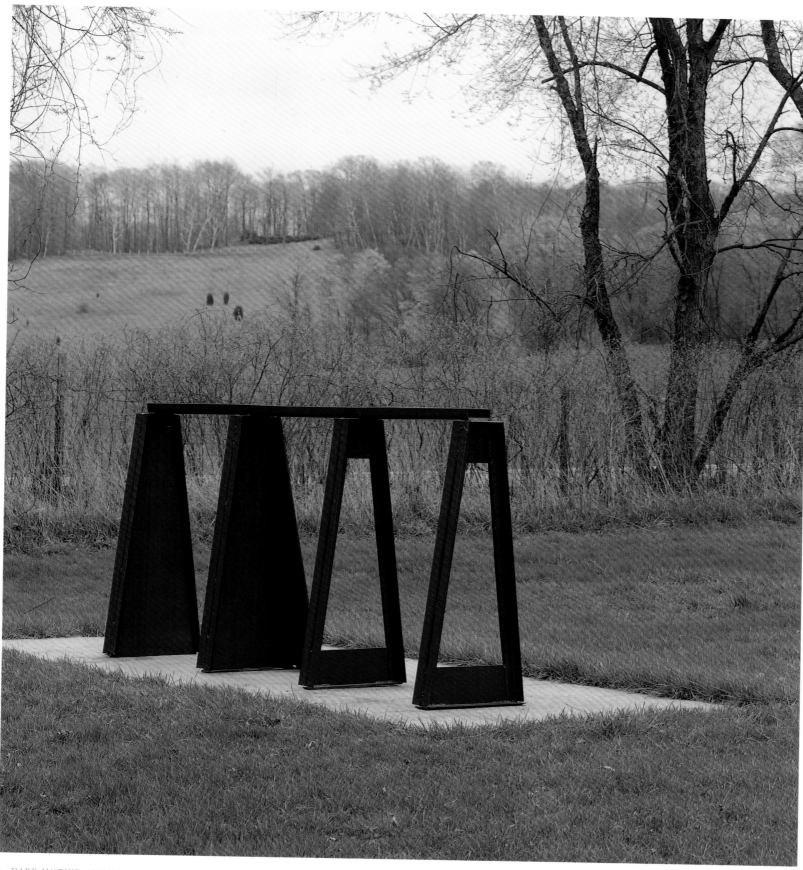

5. DARK MOTIVE 1971/74

6. SMOULDER 1965

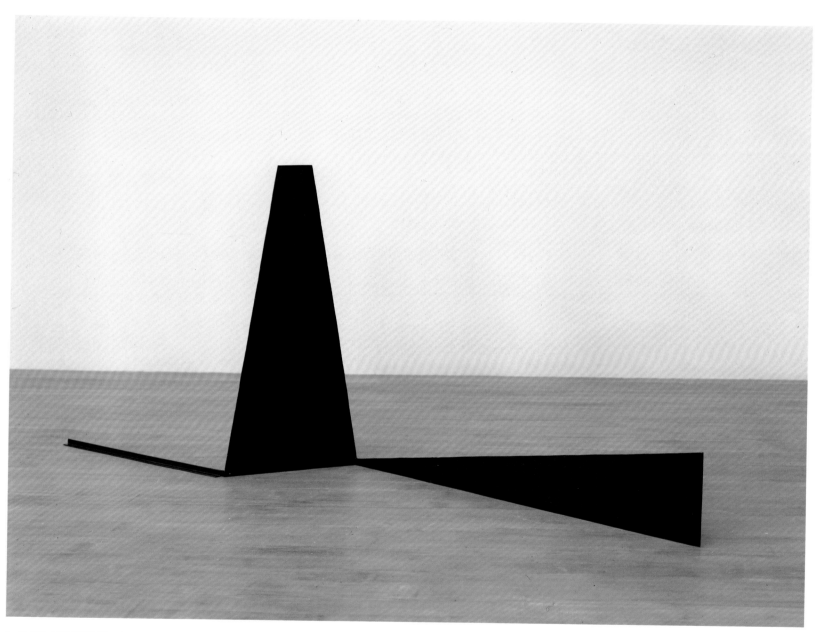

7. SLOW MOVEMENT 1965

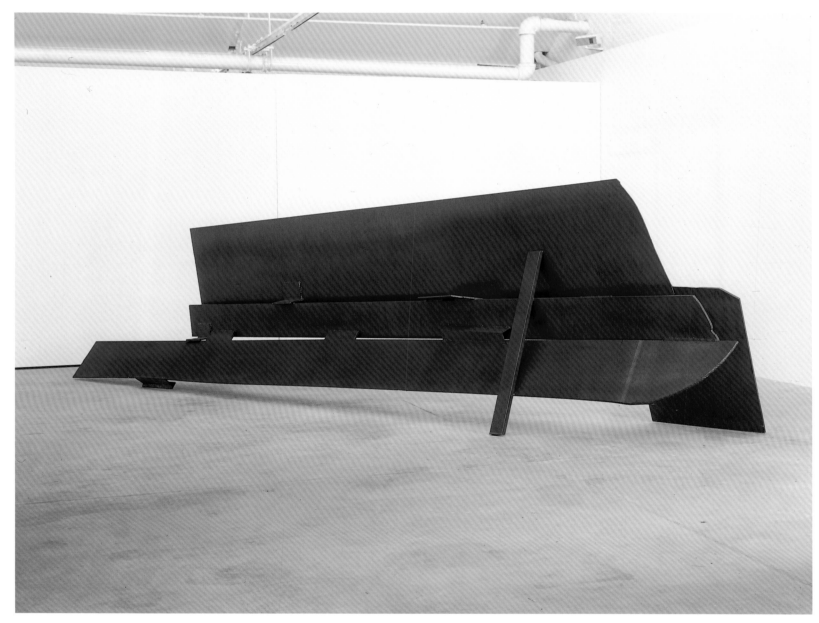

8. SKIMMER FLAT 1974

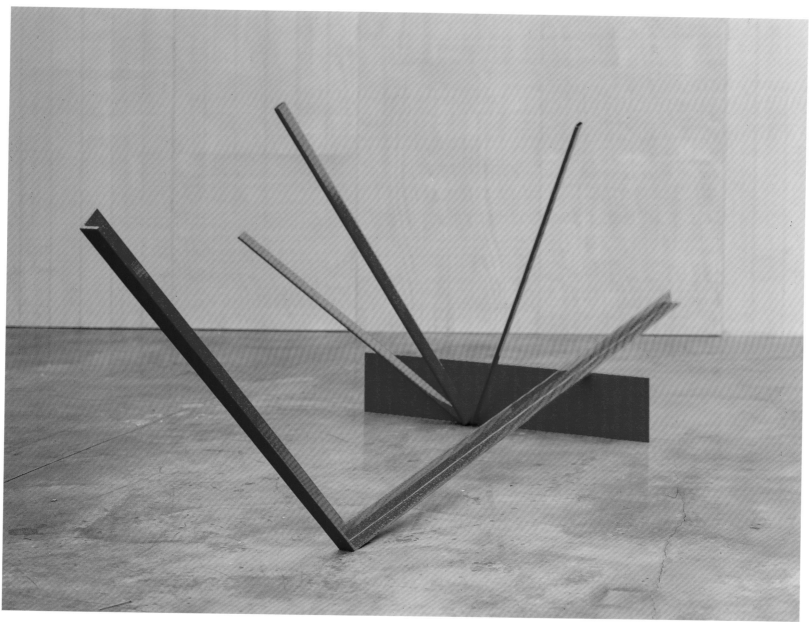

9. WIDE 1964

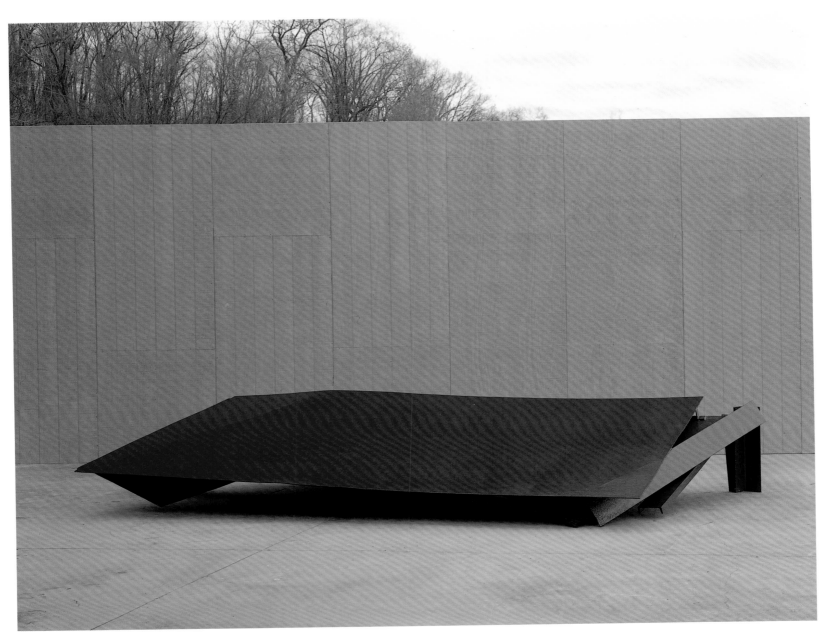

10. THE BARRENS FLAT 1974

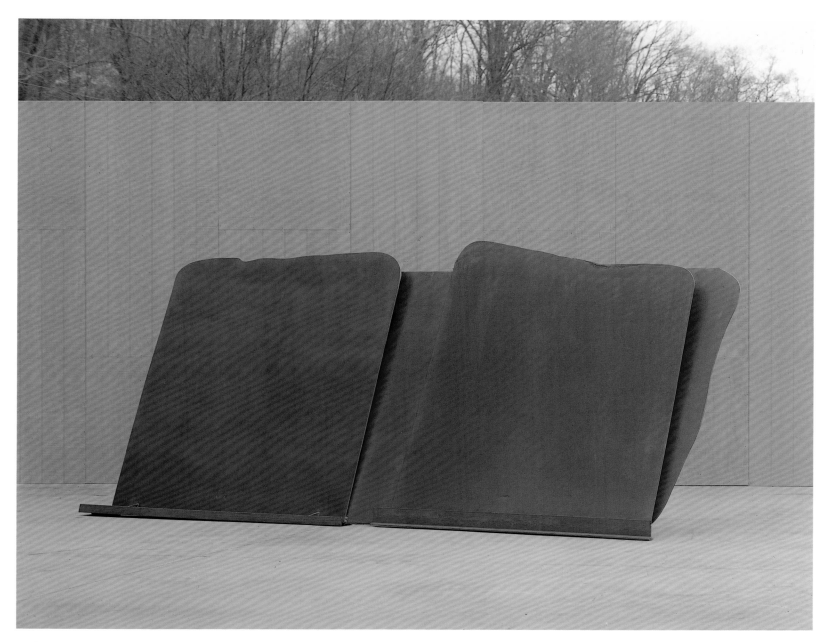

11. DOUBLE FLATS 1974

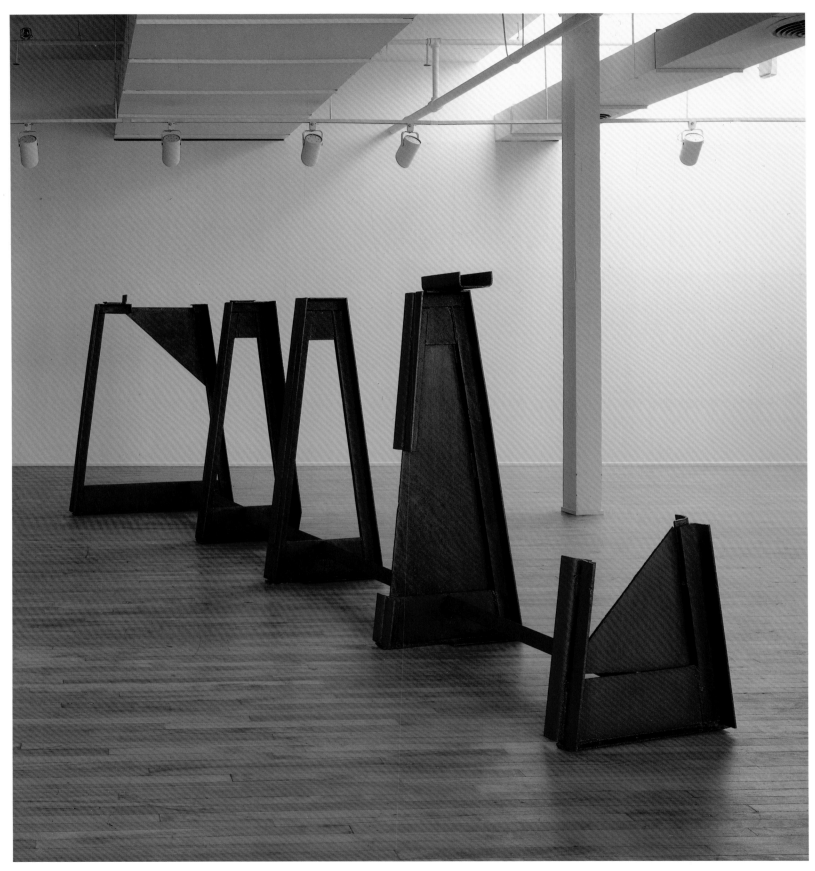

12. END GAME 1971/74

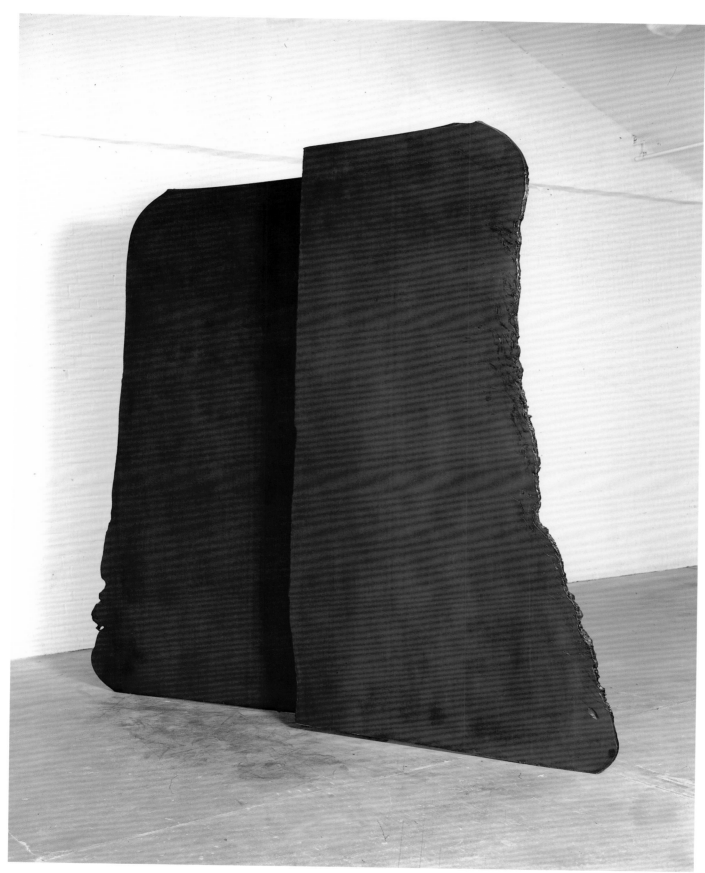

13. LAKE ONTARIO FLATS 1974

DRAWING
IN
SPACE

CARO'S EARLY SCULPTURE could be the work of a master juggler, someone with none of the sculptor's habitual anxiety about making things stay together and stand up. Even in his first abstract works, made of sturdy industrial members, their very real weight and substance is not an issue. The sculptures occupy space effortlessly, regardless of the size or bulk of their components. In slightly later works, made of thin delicate elements, this exemption from the dictates of gravity is even more striking.

Almost everyone who has commented on these sculptures has been fascinated by their apparent weightlessness, by the way each element seems physically independent of its fellows, as if the entire sculpture were fixed in space. If Caro's first abstract works were like unignorable, unnameable *things* thrust into our environment, the works that followed were like drawings made solid, magically suspended in mid-air. It is a notion that seems completely counter to the defiantly literal aspect of Caro's work, counter to his desire to 'make sculpture real', but the tension between what we see and what logic tells us must be there makes the works even more immediate. It is worth recalling a 1964 conversation between Caro and his painter friends, Kenneth Noland and Jules Olitski. Olitski said that for him, the ideal situation would be to spray colour into the air and somehow have it remain there. Caro has made sculptural equivalents of Olitski's ideal disembodied paintings.

He first made sculptures of this type in the early 1960s, but the notion of 'drawing in space' has persisted throughout his career. Sometimes in works like *Deluge* (22), drawing is like a flourish in the air, a visual extravaganza that utterly ignores sculpture's traditional concerns with mass, weight, and volume. At other times, as in the splay-legged *After Emma* (19, 20), drawing describes non-existent volumes, transubstantiating those concerns into line. What remains constant is a sense of wit and playfulness, of bravura manipulation, as if the hand that made the sculptures was quicker than the eye that perceives them.

Some of these works' rambunctious, teasing spirit is due to Caro's deliberate confusion of supporting and non-supporting elements. It is rarely evident, even with close attention, just what is there to hold the sculpture up and what to delight the eye. Even when Caro makes sculptures that are relatively frank about their structural logic, such as the engaging *Writing Pieces* (23, 24, 27) or the sprightly *Catalan* series (26, 29, 30), he maintains the illusion of weightlessness and liberation. These sculptures seem to be as much about void as they are about incident; the space they occupy is generous, their drawn elements sparse. Caro's line punctuates the void, defining shapes in the air in irregular bursts. Much of the sculptures' charm derives from this unpredictable rhythm, further evidence of Caro's ability to surprise and trick the eye, like a master of prestidigitation.

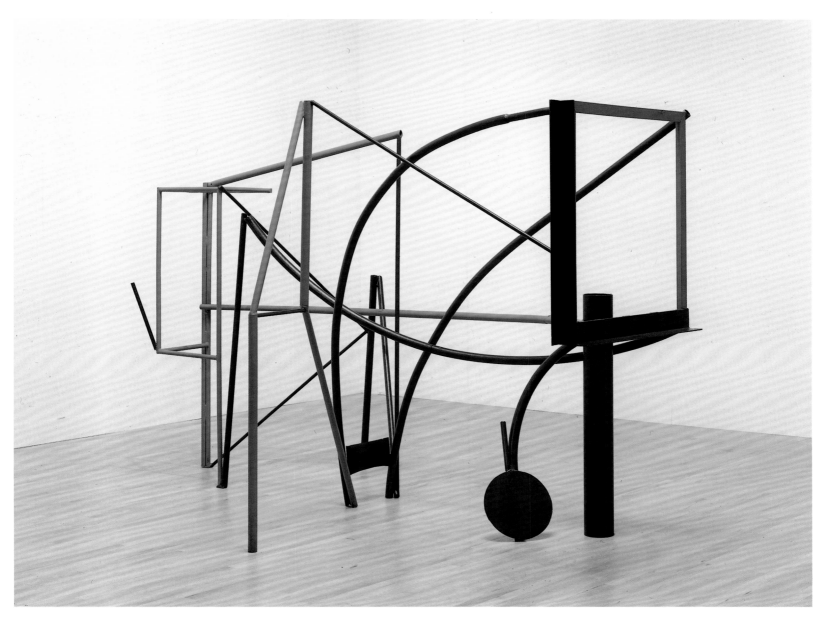

14. EMMA DIPPER 1977

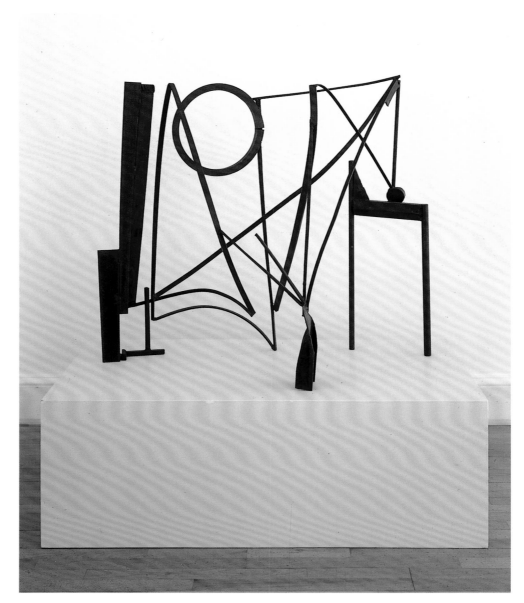

15. TABLE PIECE CCCLXXXVIII 1977

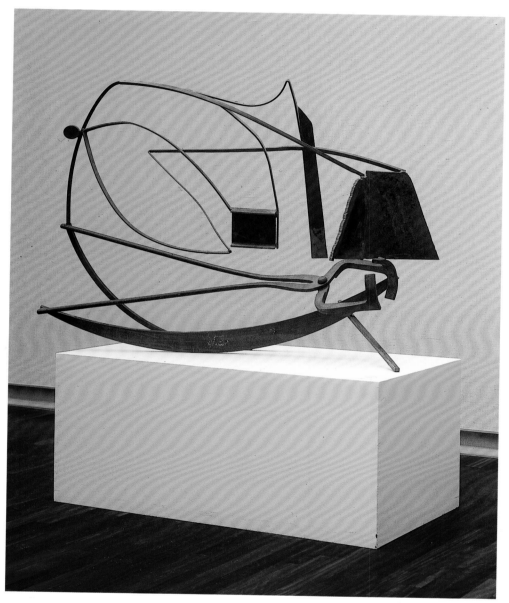

16. TABLE PIECE CCCC (FOUR C'S) 1977/78

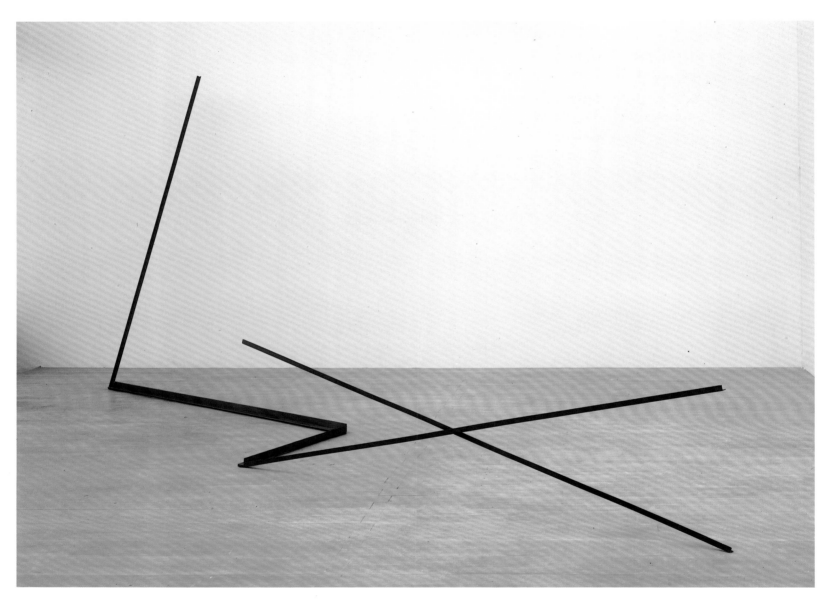

17. WANDER 1965/80

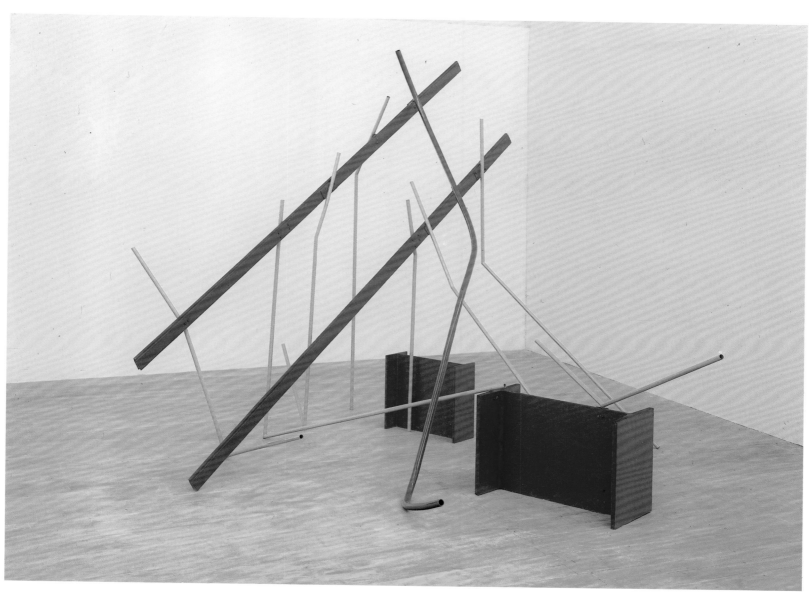

18. MONTH OF MAY 1963

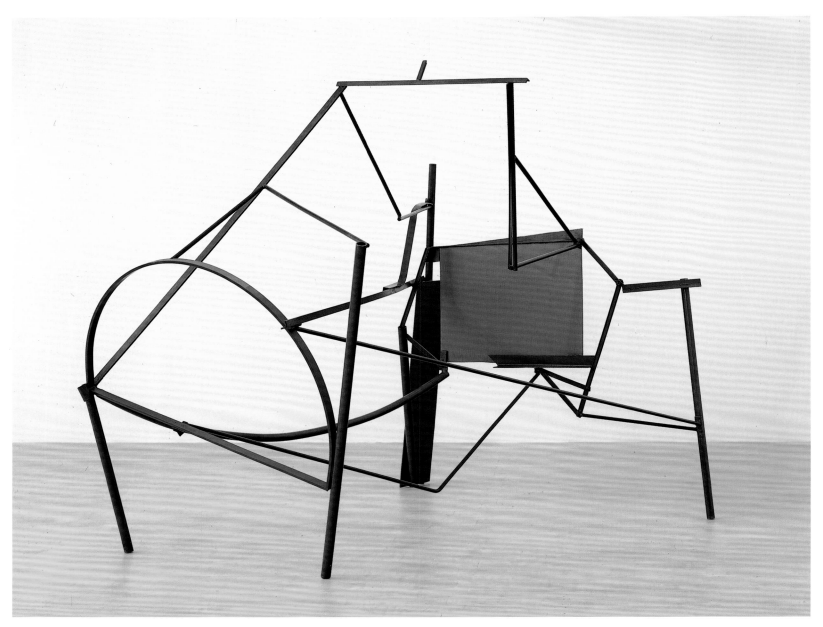

19. AFTER EMMA 1977/82

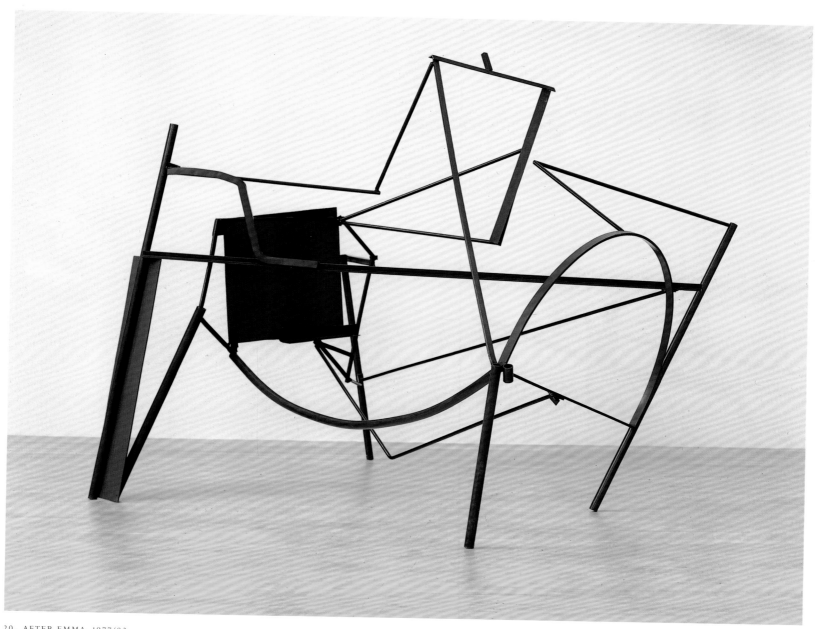

20. AFTER EMMA 1977/82

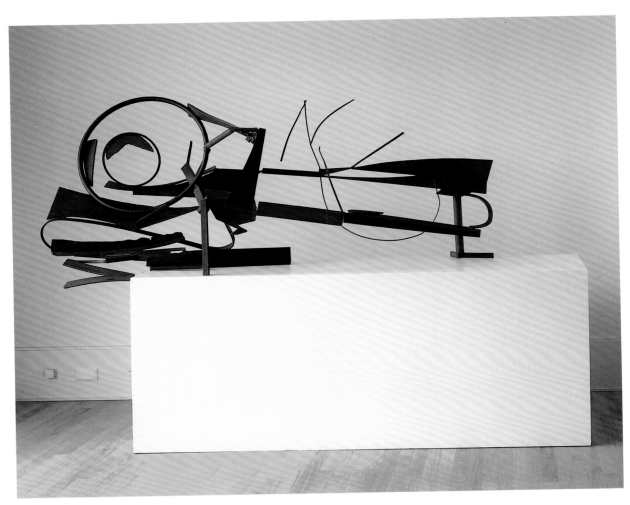

21. TABLE PIECE Z-7 'EUCLID' 1978/79

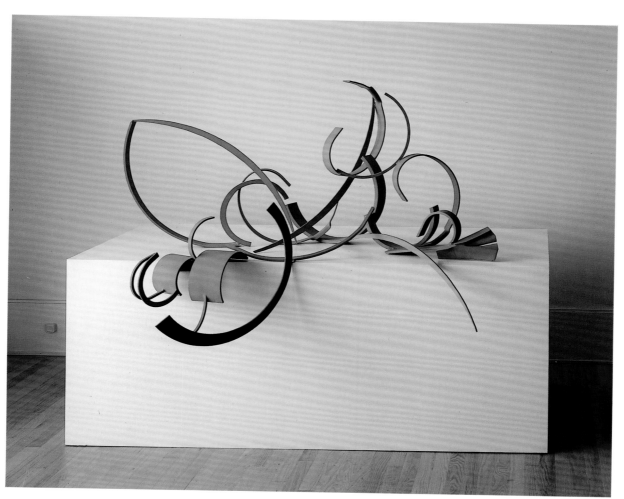

22. TABLE PIECE LXXXVIII 'DELUGE' 1969

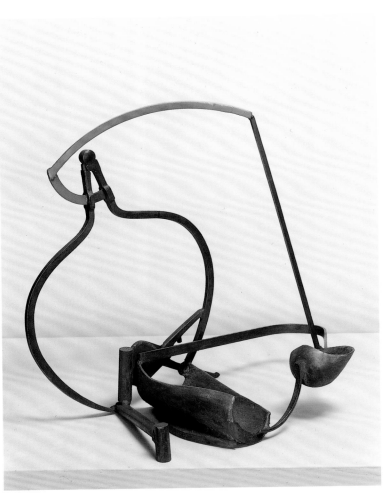

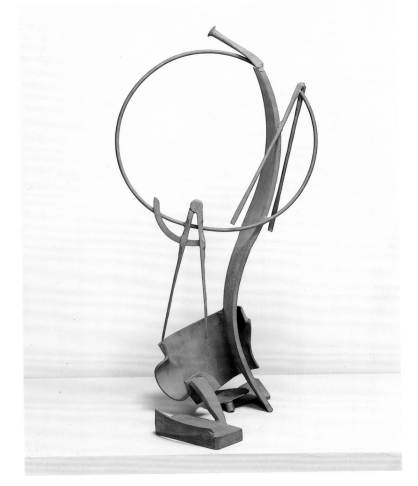

23. WRITING PIECE 'CROSS WIND' 1988/89 24. WRITING PIECE 'CONGA' 1988/89

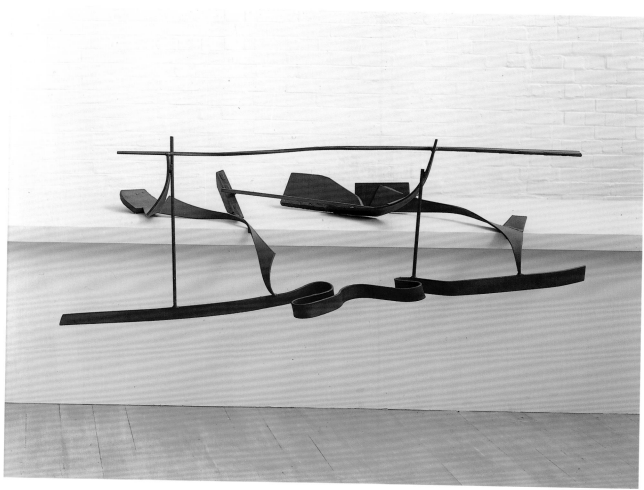

25. TABLE PIECE CCLXVI 1975

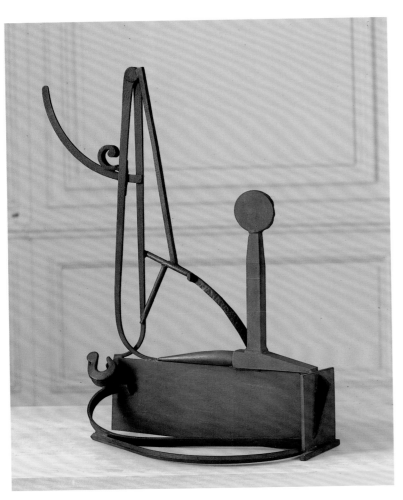

26. TABLE PIECE 'CATALAN SIGNAL' 1987/88

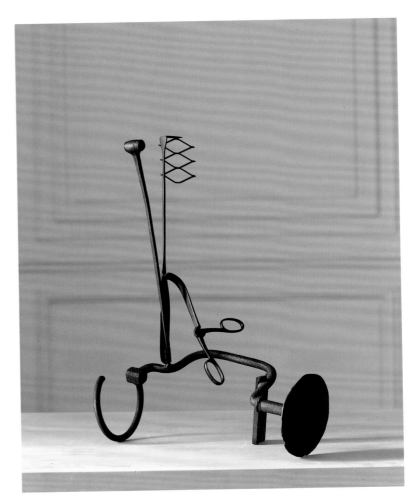

27. WRITING PIECE 'I' 1978/79

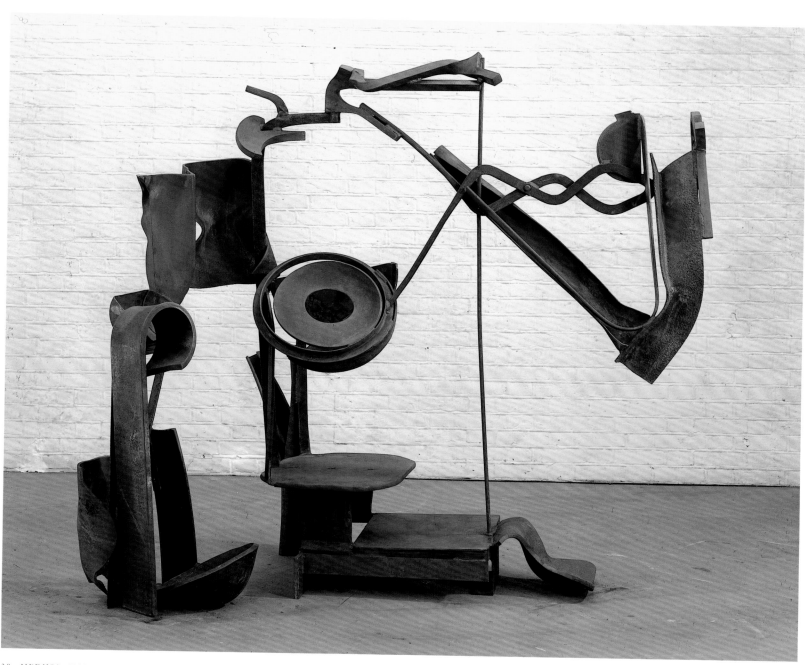

28. MEDUSA 1989

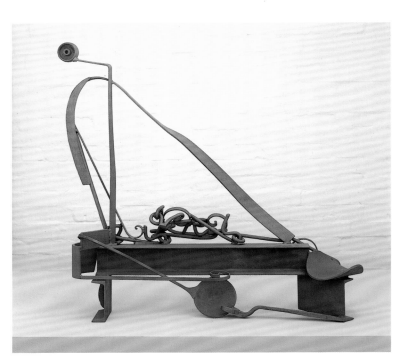

29. TABLE PIECE 'CATALAN SCRAWL' 1987/88

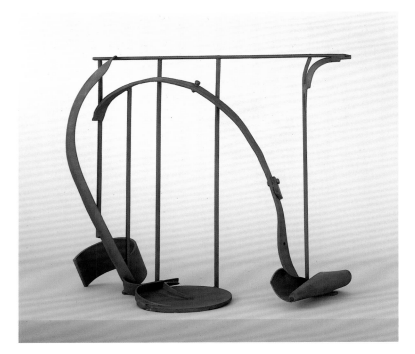

30. TABLE PIECE 'CATALAN POEM' 1987/88

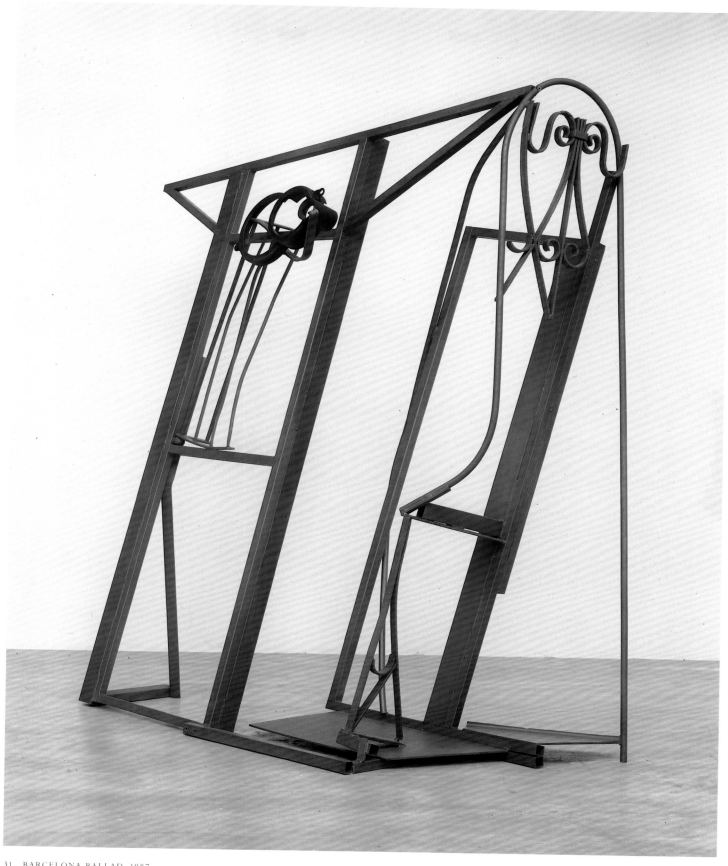

31. BARCELONA BALLAD 1987

POISE

CARO IS one of the most intuitive of artists, constantly surprising us with passages that are totally unexpected and wholly convincing. But intuition is not the entire story. His sculptures are based on a clear, purely visual inner logic. It is not easily analysed, since it depends on relationships that are cumbersome to describe, like the assonances of Henri Matisse's paintings – the astonishing pairings of dissimilar things, the echoing and inversion of shapes, the complex orchestration of patterns that declare Matisse's incomparable visual intelligence. The internal syntax of Caro's sculptures is similarly laborious to point out but instantaneous to perceive. As in Matisse's paintings, unlikeness often counts as much as likeness, dissonance as much as accord.

What holds a Caro together and makes even the most disparate elements coalesce into sculpture is placement. The intervals between elements, the way sections of I-beam and unnameable shapes touch or separate, the way planes and bars tug at one another across a void or turn away, all become expressive elements in a Caro sculpture. The manner in which he arranges even the most recognisable structural forms and found objects subverts any recollection of their real function and turns them into purely sculptural elements. I-beams are not used to support like I-beams; fragments of actuality lose their identities by being placed in unexpected positions, in unlikely dialogue with other elements. Whatever the previous existence of Caro's components, he transforms them with the force of his will and the mark of his hand, subordinating them to new wholes by virtue of placement.

Caro's best sculptures seem to happen as we look, as if momentarily stilled in an inevitable configuration, perfectly in equilibrium but ready to move, like a dancer at the culminating point of a phrase. 'A sculpture has to have that feeling of being alive, of jumping, dancing almost,' Caro says. Dance, with its tension between balance and imbalance, between rhythm and syncopation, between poise and motion, may offer the most accurate analogy of all. At their best, at their most eloquent, Caro's sculptures thrust through space. They stretch, bend, and rebound with the grace, energy, and power of the very greatest dancers, the ones who can turn the virtuoso execution of a chain of steps into a three-dimensional code for thought and feeling.

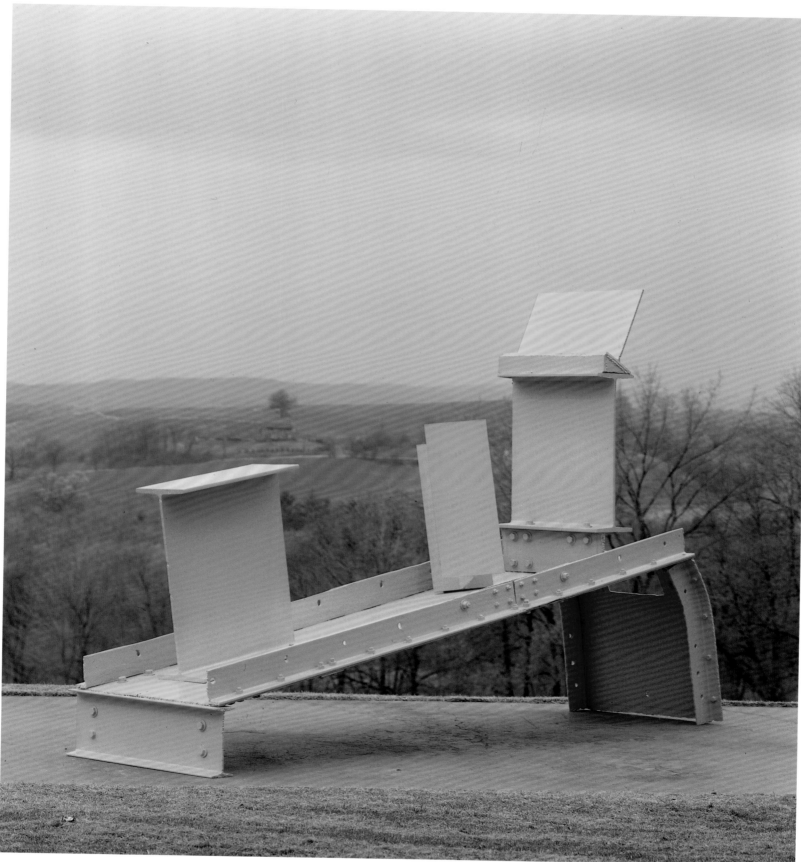

32. MIDDAY 1960

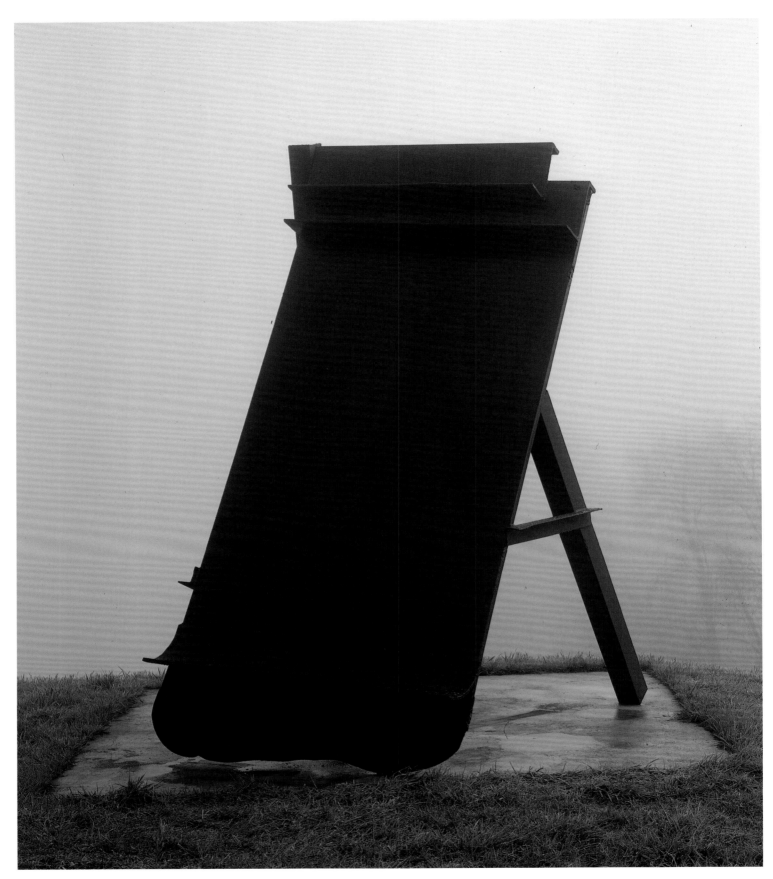

33. OVERTIME FLAT 1974/75

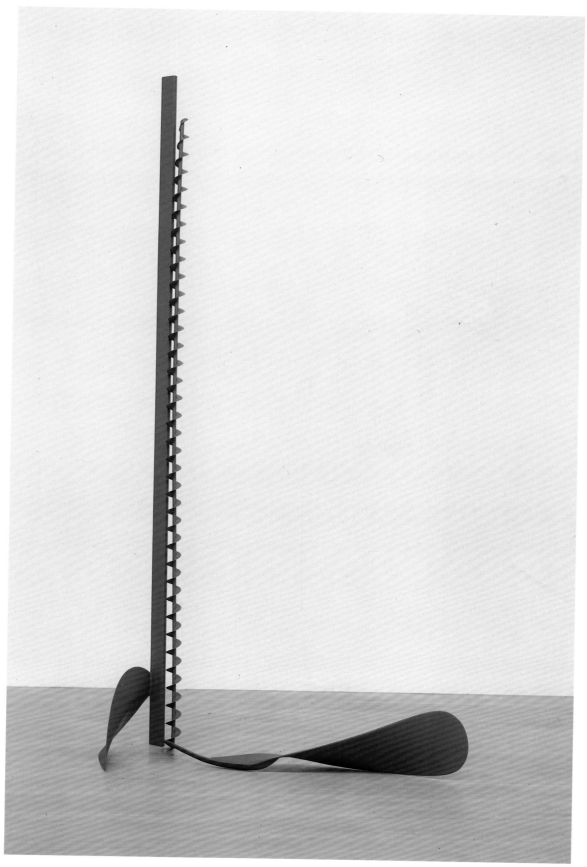

34. WHISPERING 1969

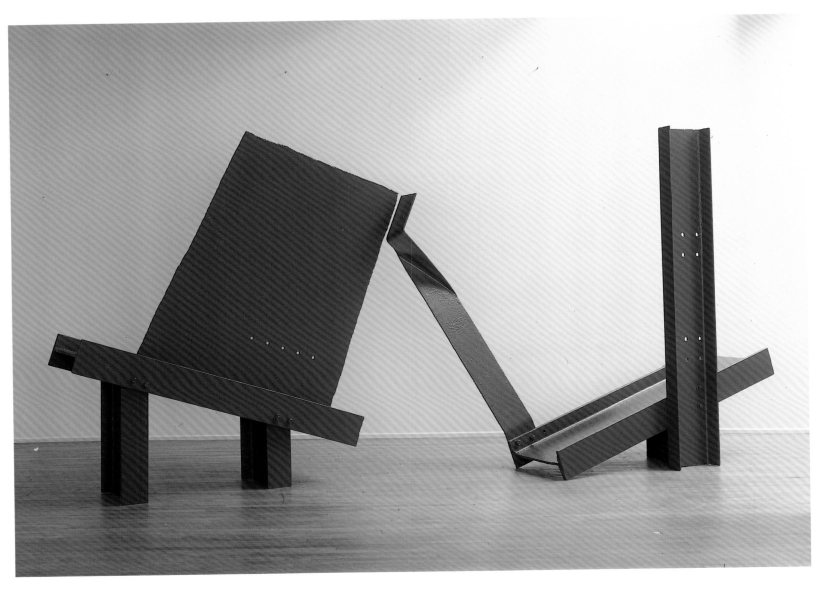

35. THE HORSE 1961

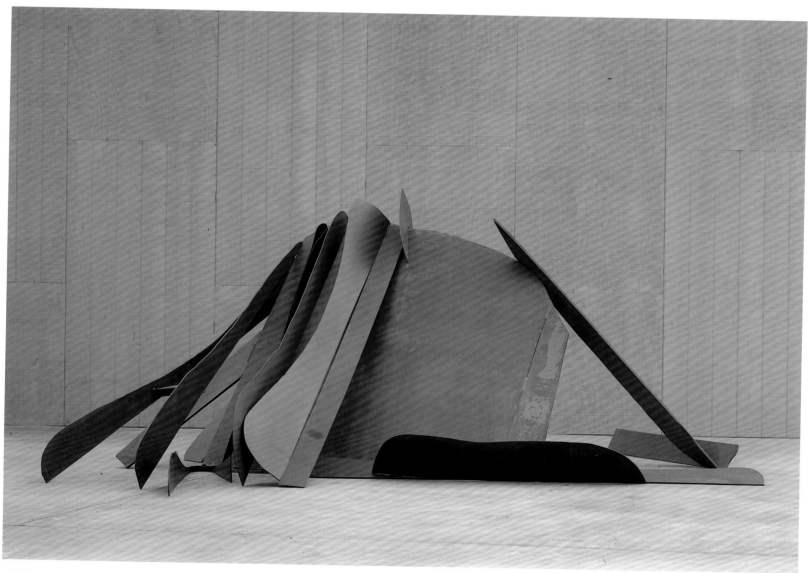

36. CURTAIN ROAD 1974

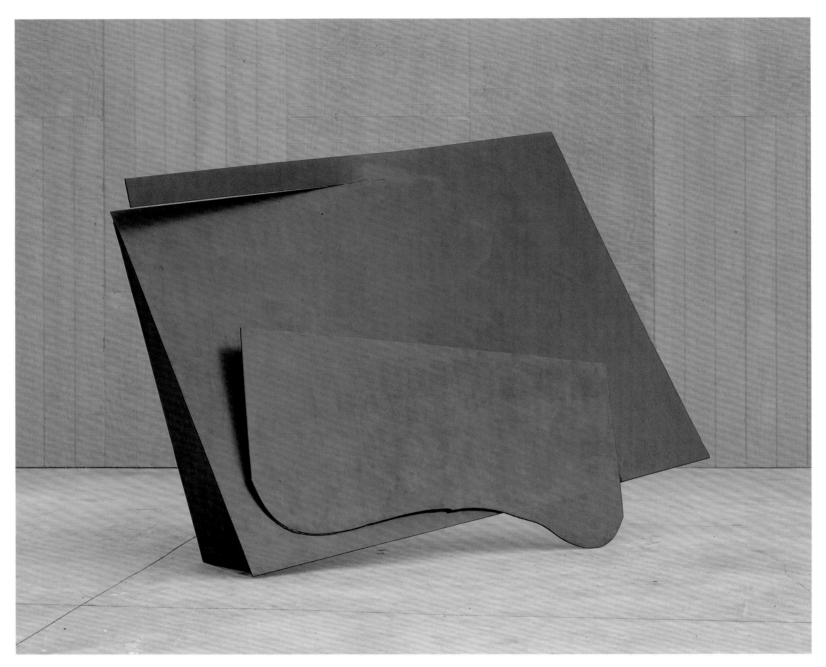

37. PIN UP FLAT 1974

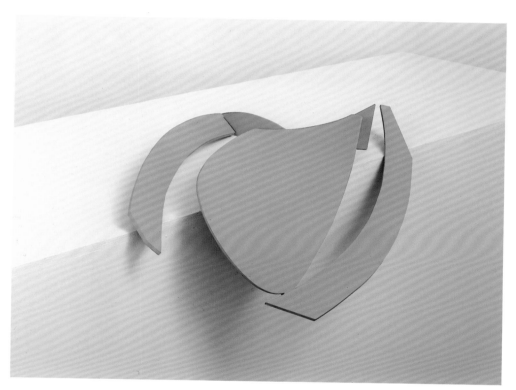

38. TABLE PIECE LXXV 1969

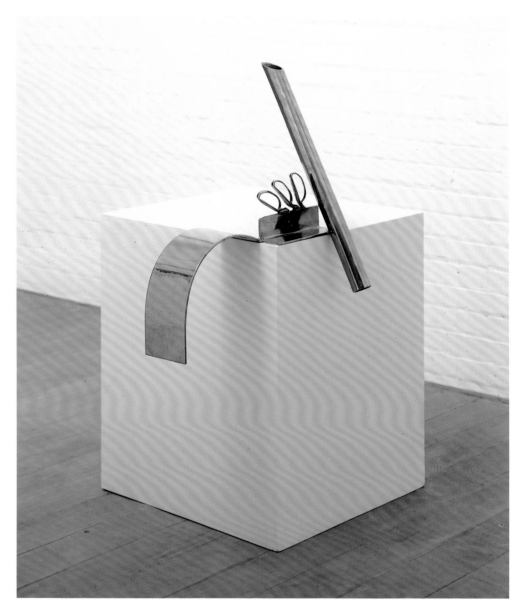

39. TABLE PIECE VIII 1966

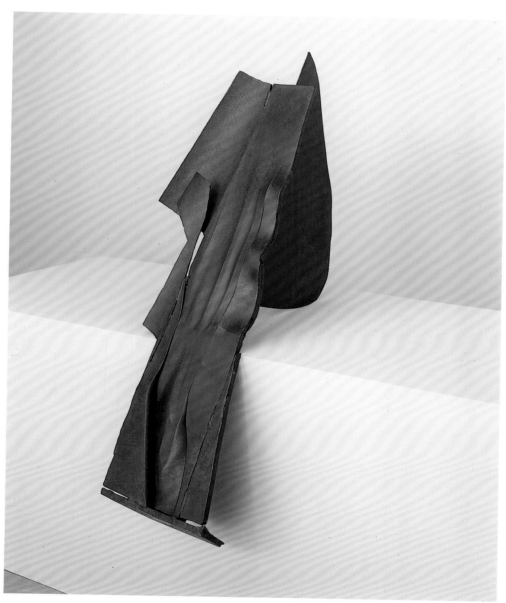

40. TABLE PIECE CLXIII 1973

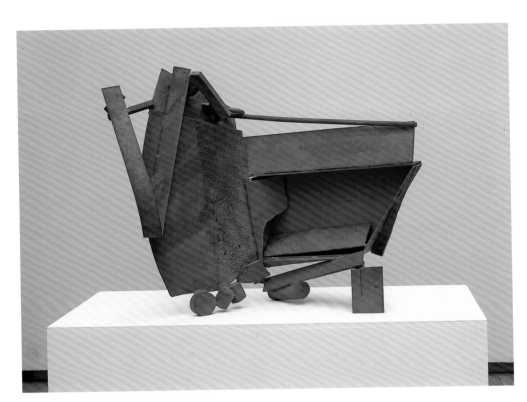

41. TABLE PIECE Z-85 'TIPTOE' 1982

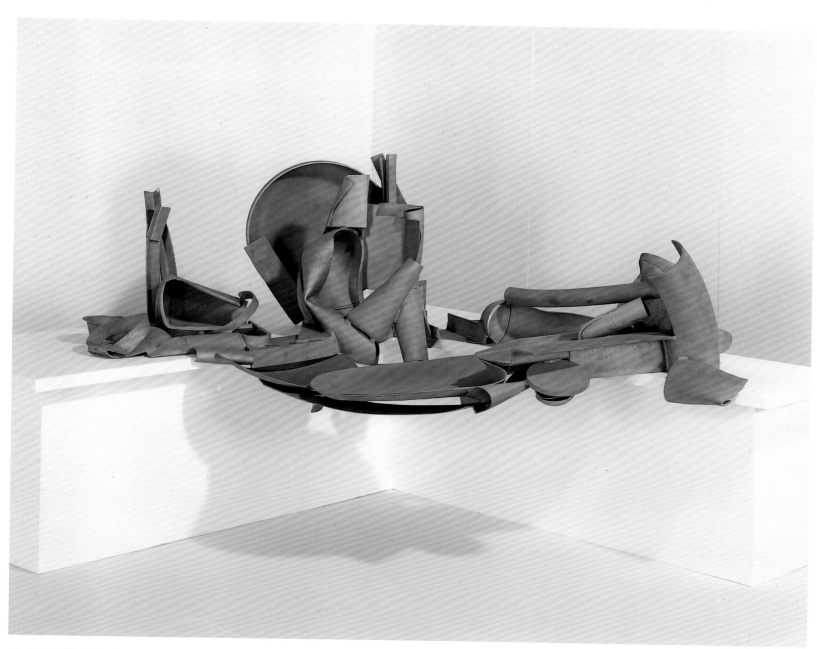

42. DEJEUNER SUR L'HERBE II 1989

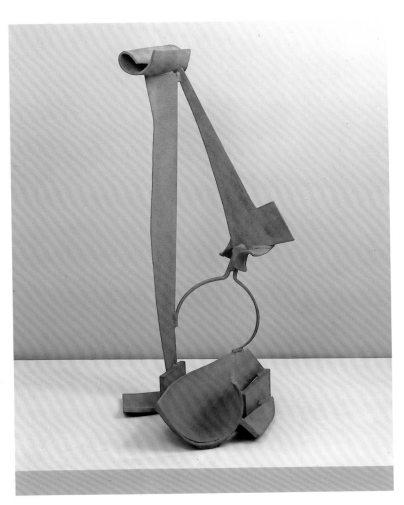

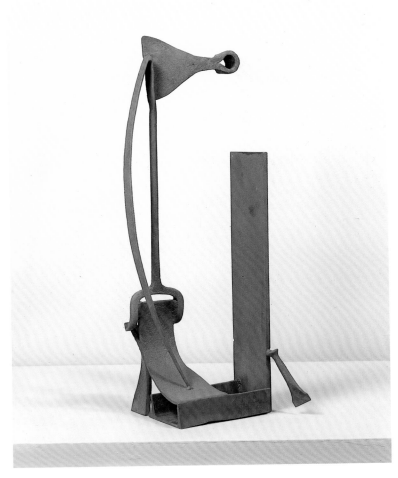

43. TABLE PIECE 'BREEZE' 1988/89

44. WRITING PIECE 'STANDARD' 1988/89

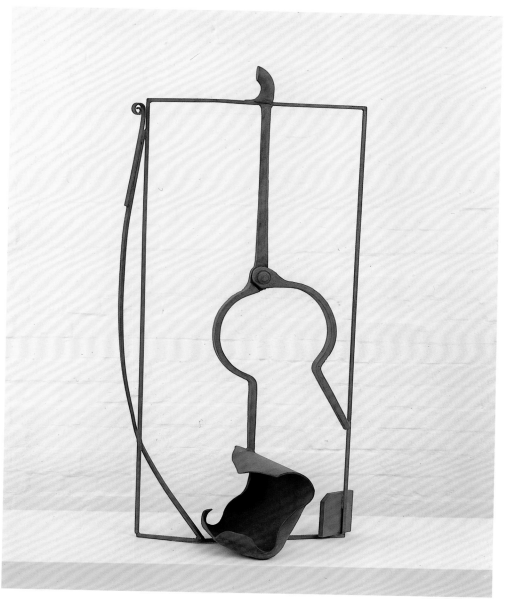

45. TABLE PIECE 'CATALAN MAID' 1987/88

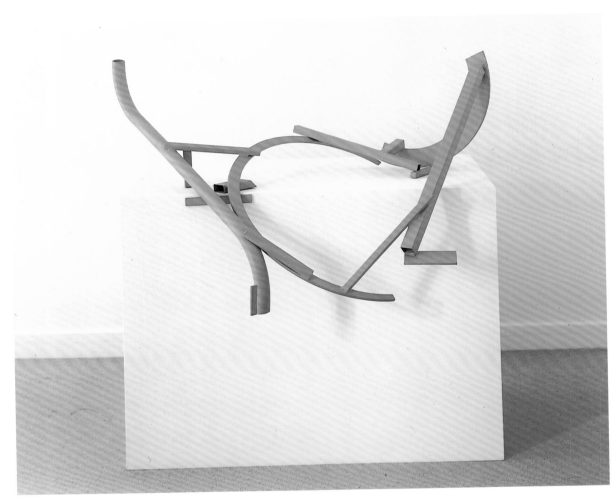

46. TABLE PIECE 'THE CLOCK' 1968

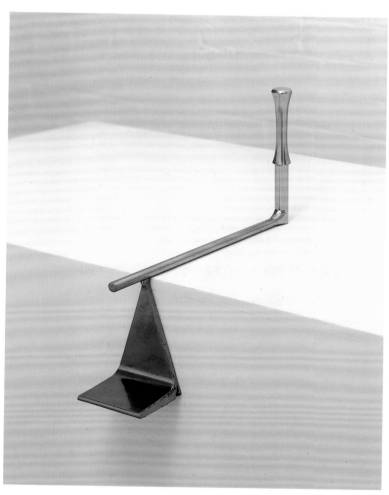

47. TABLE PIECE VII 1966

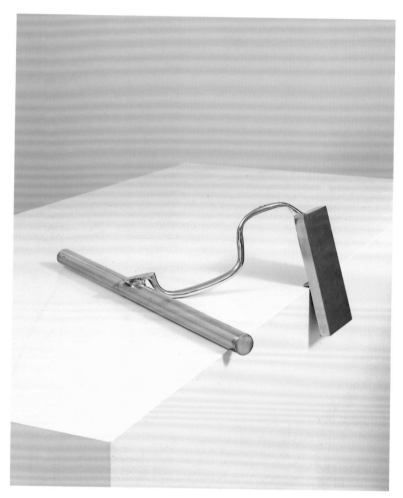

48. TABLE PIECE XVIII 1967

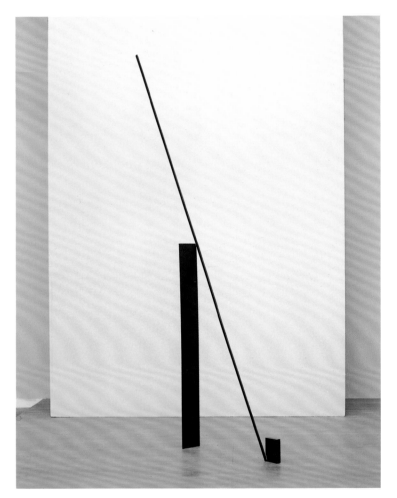

49. PITCH 1967

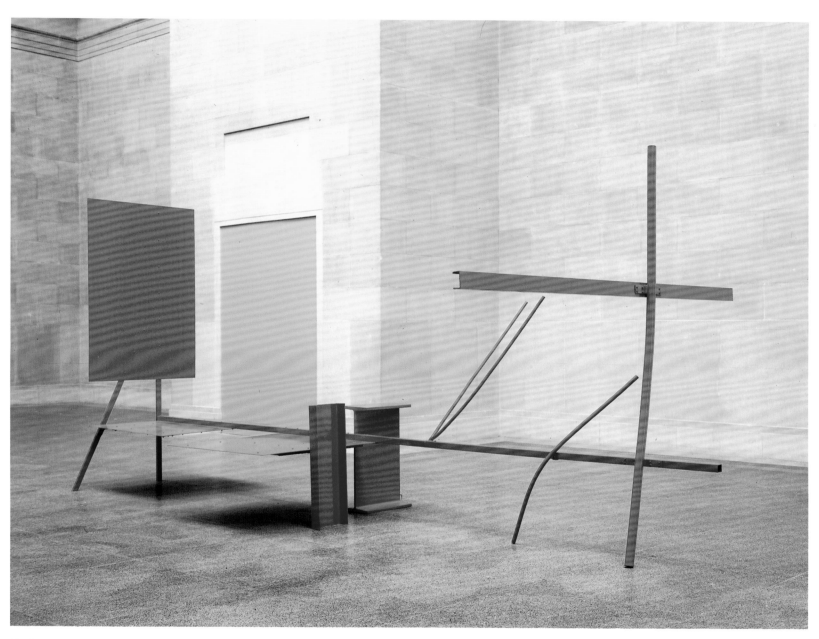

50. EARLY ONE MORNING 1962

LEVELS

ARO'S SCULPTURES frequently restate the ground plane from which they depart, even when they rise effortlessly above it, as if their apparent weightlessness, their seeming negation of gravity, were still conditioned by the even-handed pull of that underlying horizontal expanse. He often constructs works in a series of levels, broad strokes parallel to the ground that in some sculptures lead us upwards, like overscaled stairs, and in others, serve as potent embodiments of compression. In some works, this insistent restatement of levels creates a surrogate horizon – or horizons – further separating the sculpture from earthbound actuality, and declaring its autonomy.

'I often think of these horizontals like the staves of musical notation,' Caro says, 'or like a scale. I sometimes think of a sculpture like a concerto. There's the piano up above and the orchestra down below.'

It seems impossible that we could see large pieces of industrial metal as anything as ethereal as a cascade of notes, but, in fact, Caro's sculpture elicits this kind of willing suspension of disbelief from its viewers. *Ordnance* (63), for example, is, at first glance, a deadpan pile of beams and struts, so reminiscent of vernacular building motifs that it is tempting to dismiss it as an arrangement of standard steel parts according to standard steel usage. Longer viewing upsets this judgement, as we become aware of the intervals between the sculpture and the ground plane. The space between elements is as resonant and as interesting as the elements themselves. What is supported is less evident than the way the piece slowly rises, becoming increasingly mysterious and poetic. *Ordnance* functions, in part, as a kind of diagram of the force field between two powerful horizontals – the levitating beams on their zig-zag struts and the ground plane – between man-made structure and its context.

Hop Scotch (54), on the other hand, looks as if Caro had flung an armload of shiny metal into the air and willed it to stay there. The slender horizontal bars appear to have no supporting function at all, but serve to measure the heights reached by the floating diagonal bars. Size differences between these bars create a fleeting perspectival illusion, so that they appear to tumble and drift away from us, wheeling in space. Yet, at the same time, everything seems exactly where it should be, transfixed in an unstable harmony.

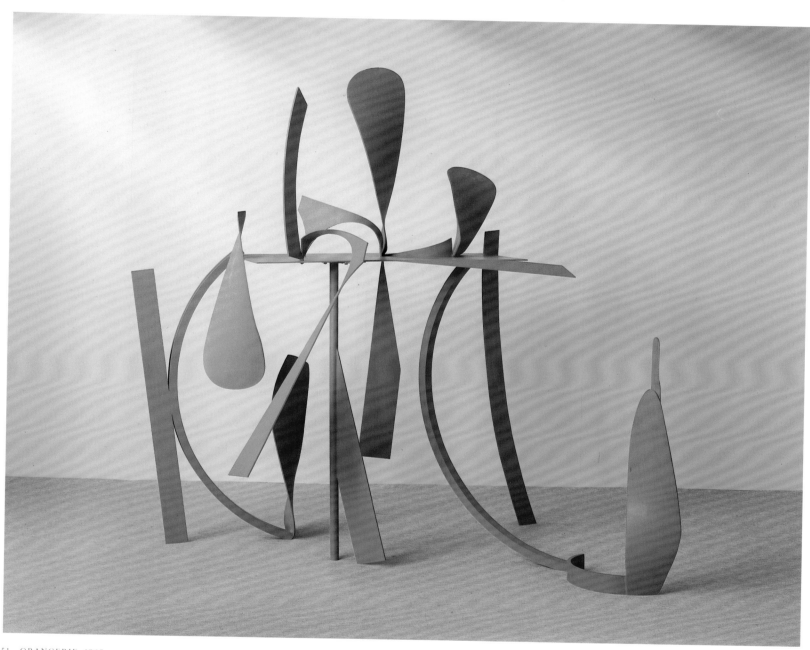

51. ORANGERIE 1969

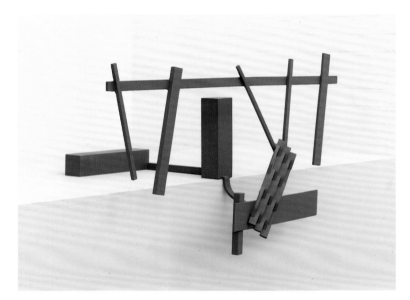

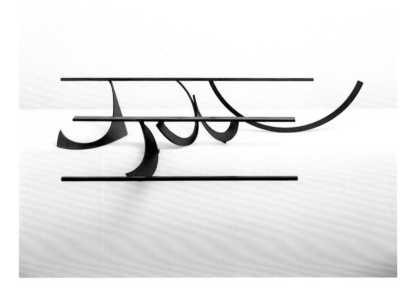

52. TABLE PIECE L 1968 53. TABLE PIECE LXXX 1969

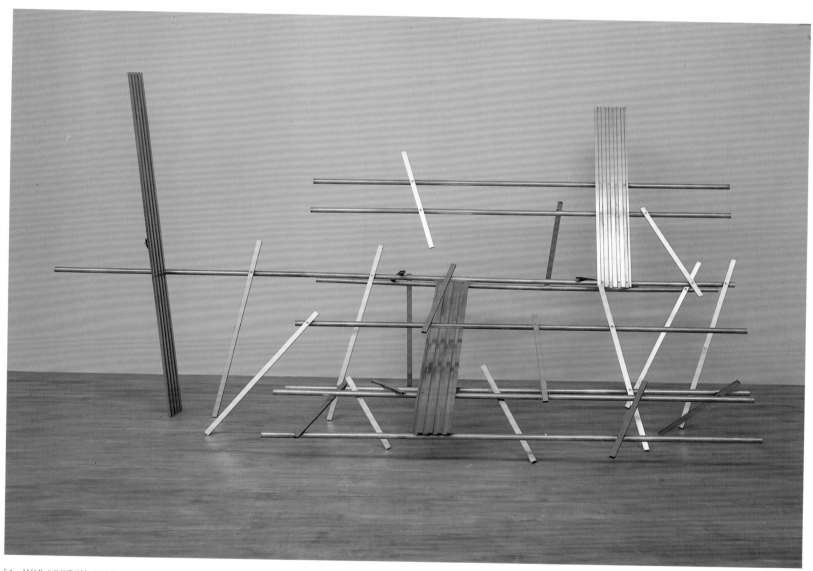

54. HOP SCOTCH 1962

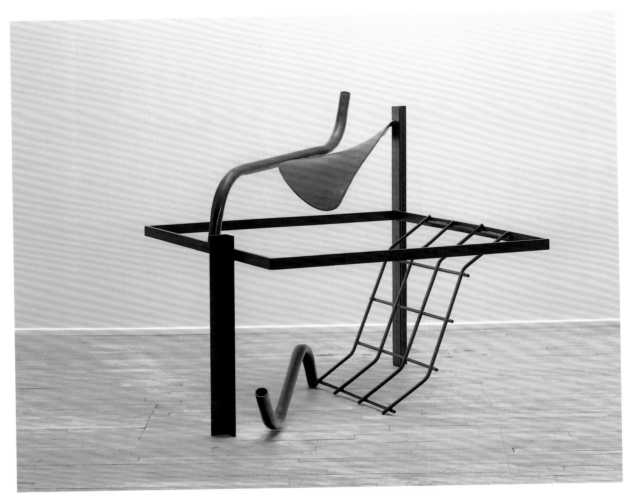

55. TEMPUS 1970

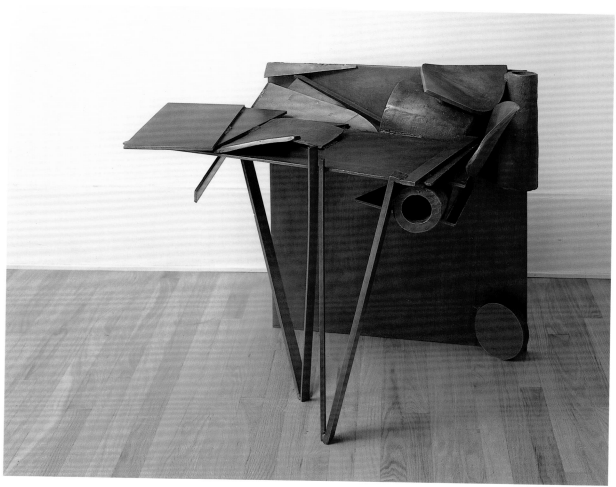

56. ICE HOUSE 1977/78

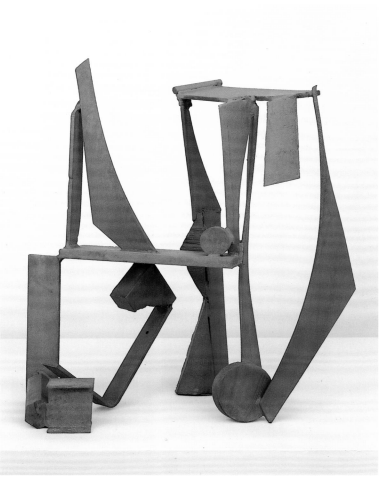

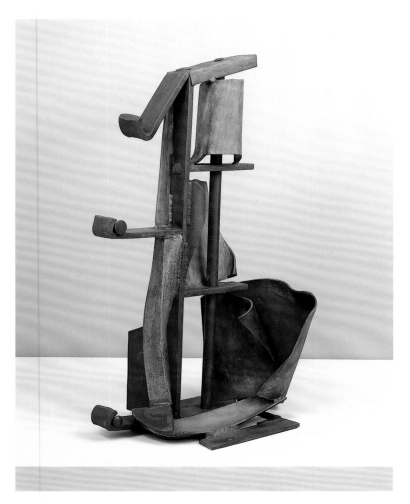

57. TABLE PIECE Z-44 1979/81

58. LADDER SONG 1988/89

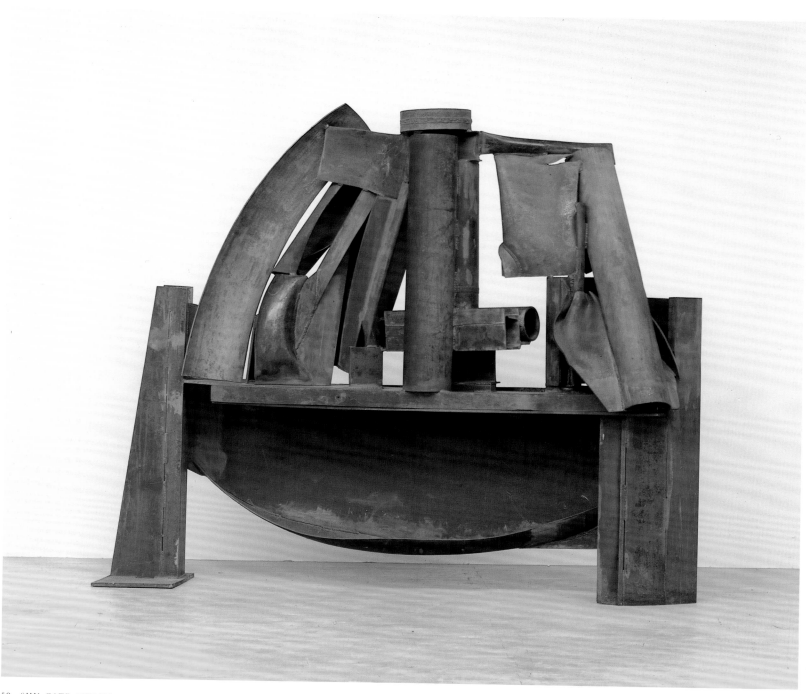

59. SUN-GATE 1986/88

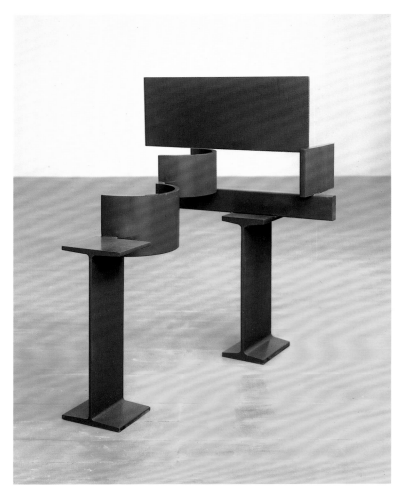

60. TANTUM 1970

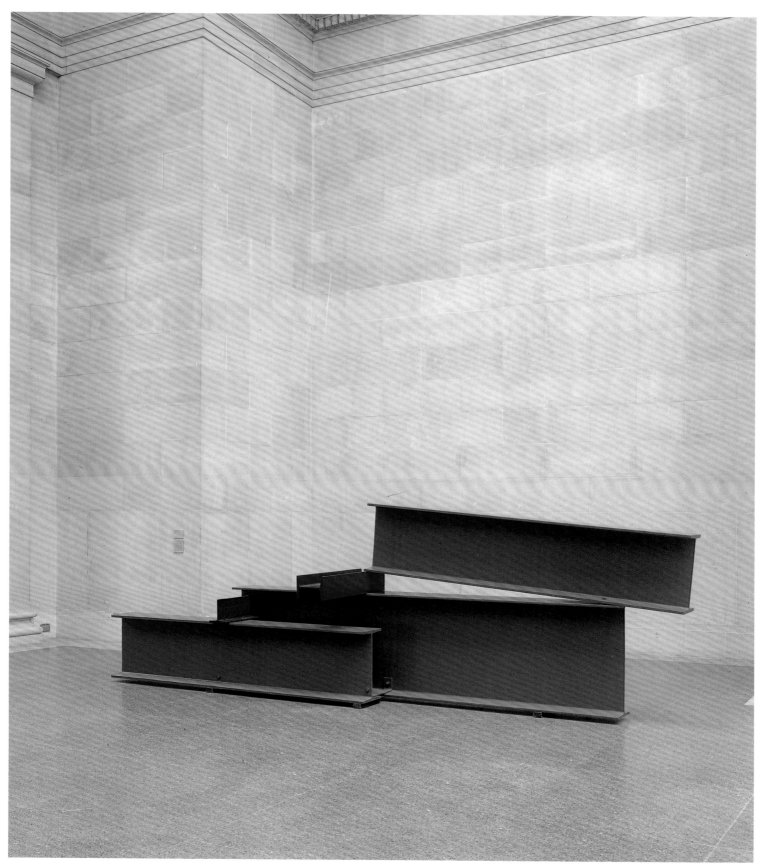

61. SCULPTURE SEVEN 1961

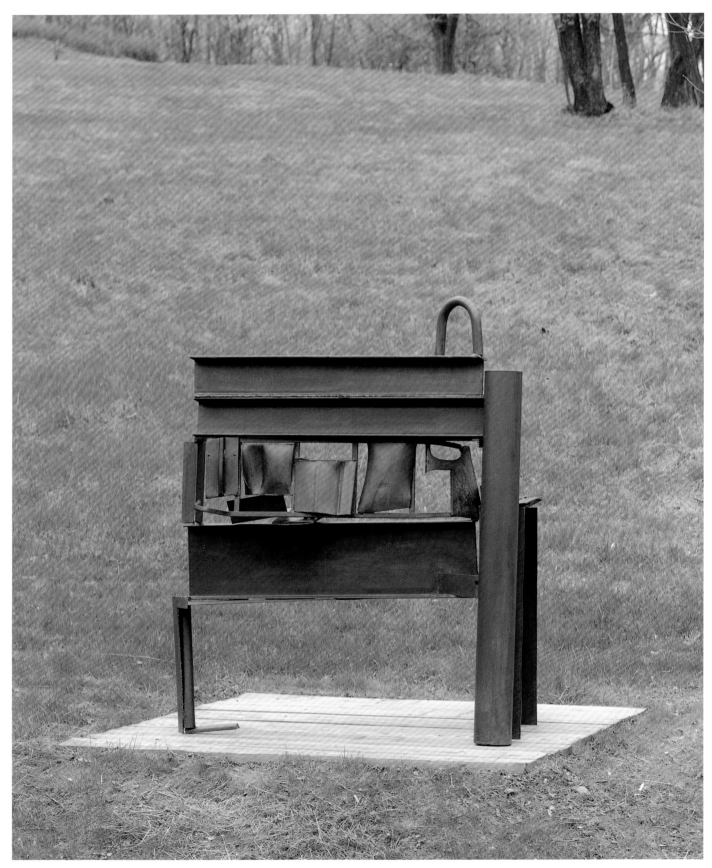

62. EMMA BOOKS 1977/78

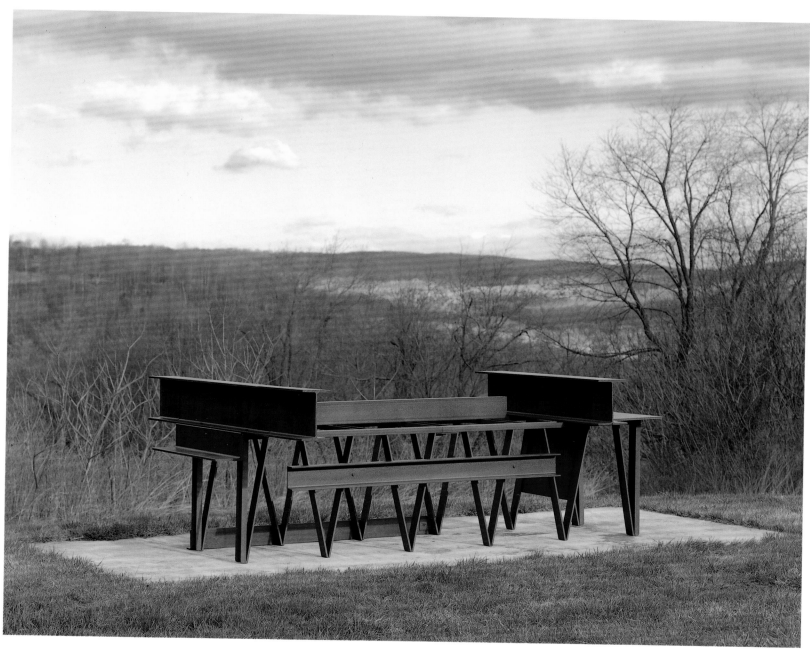

63. ORDNANCE 1971

VESSELS

CARO HAS OFTEN said that sculpture can be utterly pictorial and open or utterly physical and dense, or anywhere in between. While his abstract sculptures of the 1960s were remarkable for their transparency and lightness, his work since the early 1970s clearly has embraced new ideas about volume and enclosure. Caro continues to make works that are essentially drawing-like, often at the same time that he is working on massively dense sculptures, but even the most linear of these pieces deals more overtly with contained, albeit outlined, volume than anything that preceded it.

Many of Caro's works since the mid-1970s have included elements that are literally vessel-like or container-like. Their convexities and shadowy interiors add another colour to his palette, broadening the tonal range of his work. It is as if he had begun to draw with broad brushstrokes and shades of grey, instead of restricting himself to the crisp black and white line of his 1960s works. Or, to pursue the musical analogy that Caro himself often uses, he seems to have begun to explore more complex chords in his harmonies.

In part, Caro's interest in vessel-like forms owes something to his participation in an experimental project organised by Syracuse University, in 1975. A group of leading painters and sculptors was invited to work at the university's clay department, regardless of whether they had any previous experience of the medium. Caro, of course, had modelled figurative works in clay at the beginning of his career, and had

not touched it since. Typically, he rethought the material, in terms of a vocabulary of traditional ceramic shapes and forms – broadly interpreted – made in advance and then sliced or altered, and assembled as freely and directly as steel. When Caro began to work again in bronze, soon after the clay project, he carried over this method and, to an extent, this vocabulary of swelling shapes and forms, so different from his usual lexicon of steel elements, and so evocative of bronze's ability to flow. This range of forms may, in part, contribute to the abstractness of Caro's bronzes. Far from reminding us of the material's long association with figurative sculpture, his pieces recall Chinese ritual vessels and altar furnishings.

Although these volumetric, suggestive forms have obviously enlarged Caro's visual range, the real issue is not the vessel per se, but larger ideas of containment and enclosure. Caro's early sculptures were usually completely accessible to the eye. Planes might temporarily obscure a view from one vantage point, but from another they revealed their edges and became less substantial. His newer works are more reticent. We may penetrate a sculpture from one viewpoint and be completely excluded from another, or sense an interior void from the profile of a form, without being able to see into it. Even the most intimately-scaled pieces of this type are mysterious and elusive, their half-hidden zones suggesting private, sanctified places, inaccessible to the uninitiated.

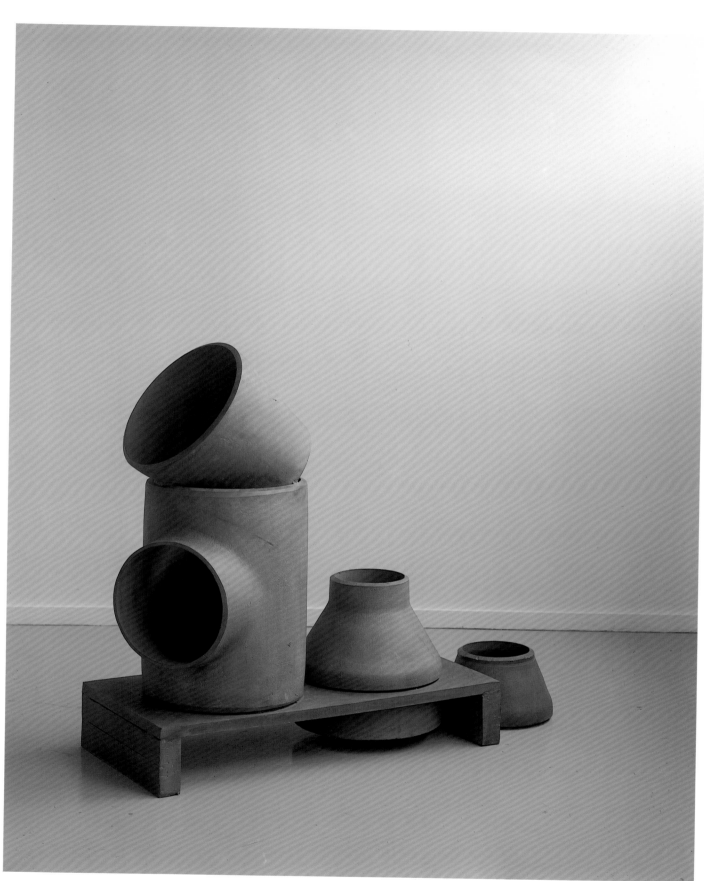

64. NORTHERN VESSEL 1989

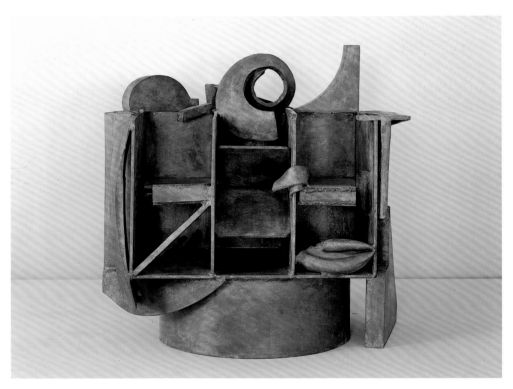

65. CHEMICAL BOX 1987

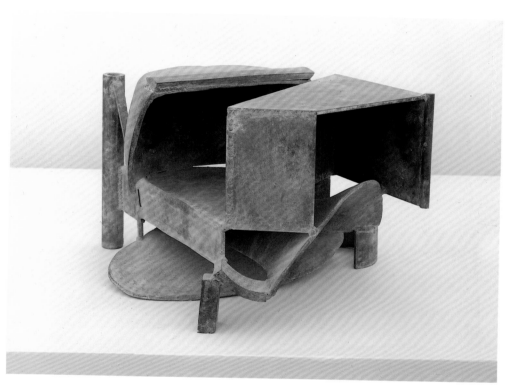

66. LATE QUARTER (VARIATION G) 1981

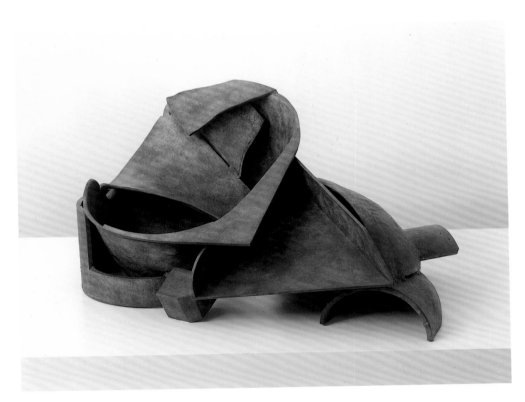

67. CAMPANELLA 1983

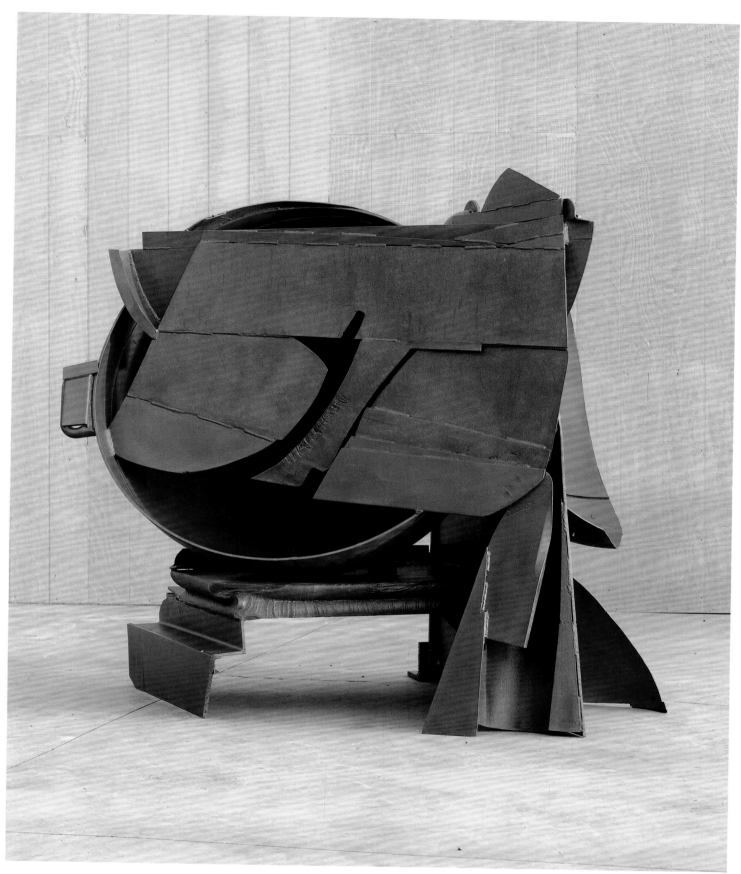

68. ANGEL BAY 1984

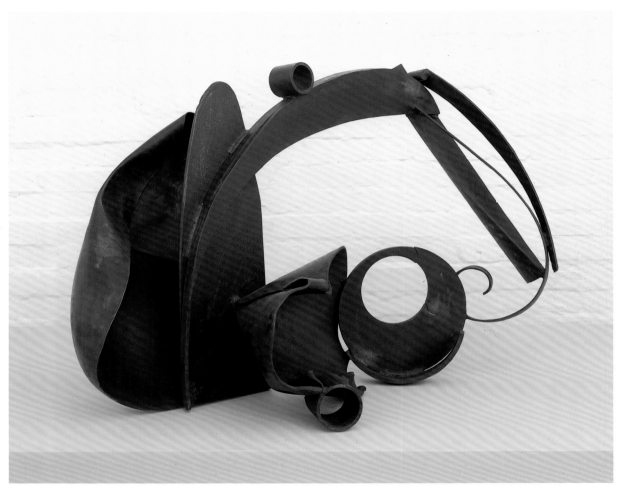

69. TABLE PIECE 'CATALAN ROLL' 1987/88

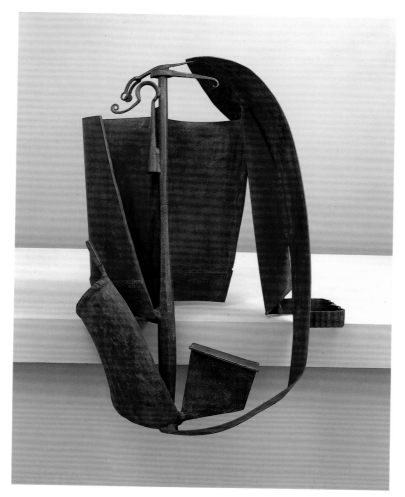

70. TABLE PIECE 'CROOK' 1988/89

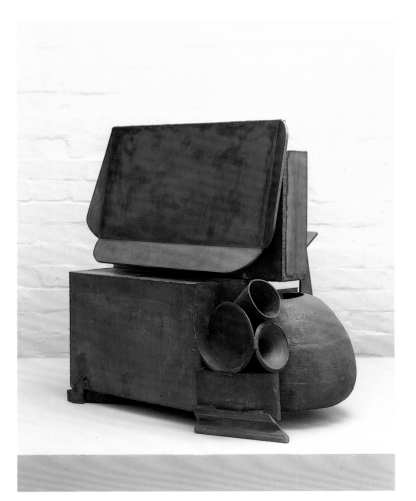

71. HALF MOON 1980

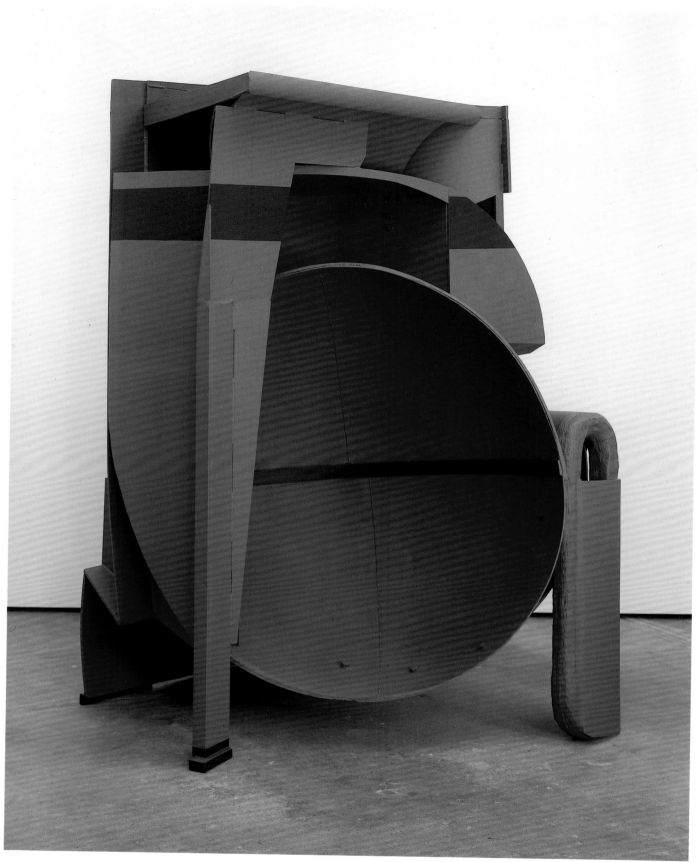

72. BLACK RUSSIAN 1984/85

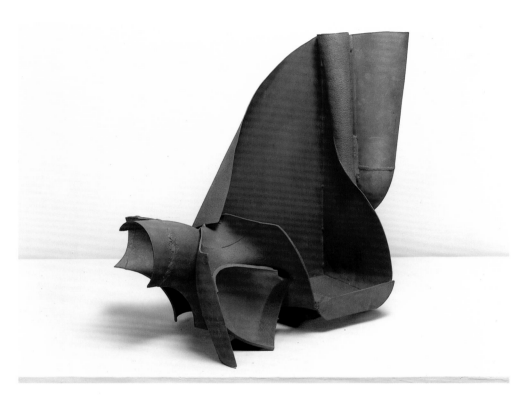

73. TABLE PIECE 'HELM' 1988/89

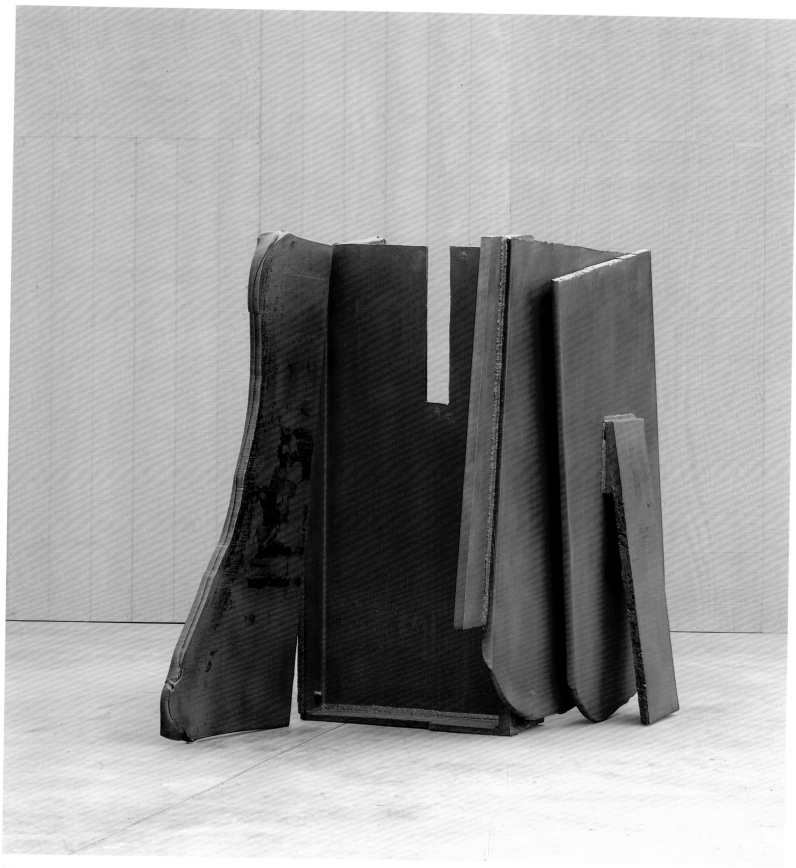

74. FOSSIL FLATS 1974

THE
TABLE

IN THE MID-1960s, Caro began thinking about a class of objects wholly unlike his 'grounded' large-scale constructions. Partly because of conversations with Michael Fried, he turned his attention to things of intimate scale. The question was how to make a sculpture of maquette size that was not a maquette. 'It had to be a thing in its own right,' Caro says, 'so I began to ask myself what else was that size and was a thing in its own right.' The objects in our daily lives that were scaled to the hand provided a clue. Their function was inseparable from being picked up or placed on a surface, and this realisation led Caro to begin a series of sculptures about what being on a table could mean. In a sense, the earliest table pieces, as these smaller sculptures have come to be known, were like reinvents of the traditional still life. Like Chardin's pellucid images of earthenware jugs and kitchen copper, Caro's table pieces dealt with the essential geometry of domestic objects, but they shifted the focus from the objects themselves to the nature of intimate scale. Because these sculptures incorporated actual grips and handles, they carried with them the memory of the hand, but since irrational placement rendered these handles inoperable, grasping and lifting were turned into purely visual concepts. A comment of Georges Braque's comes to mind. This master of the tabletop declared: 'If a still life isn't within reach of my hand, it seems to me that it ceases to be a still life, ceases to be affecting.'

Soon placement began to take precedence over what was placed and Caro's still lifes began to be something other than abstractions of portability. They launched themselves into space, tumbling off of the table top, reaching over the edge, penetrating their surroundings. 'I began to consider what made a table "a thing in its own right",' Caro says. 'Its height, the fact that it has an edge, the fact that its surface exists in relation to the hand – that all separates a table from other things.' How to express that difference?

David Smith's response to similar ideas, in a few atypical pieces, was to change heights, alter the scale of things on the table, and warp the table itself. Caro's attacks on 'tableness' were more audacious. In *Trefoil* (77), vertical arcs slice through the horizontal 'table top', confounding support and supported. *Sunfeast* (75) makes questions of above and below irrelevant.

While the literal table can persist in Caro's sculptures, it is as likely to survive by implication as by fact. In a recent table piece derived from a Manet painting, Caro has turned figures and landscape into a kind of still life. The inherent illusionism of Manet's canvas, the way bodies are situated in fictive space, has been translated into a horizontal sequence of discrete, subtly articulated parts, without any reference to the figure. Space itself has been made literal, turned into a bridging, forward thrust. Title apart, there is no sense that the sculpture refers to anything but itself, but there is, nonetheless, a curious sense of artifice, as if Caro had made the conventions of representation (albeit Manet's inspired version of those conventions) into abstract, concrete forms, displayed like objects on a table.

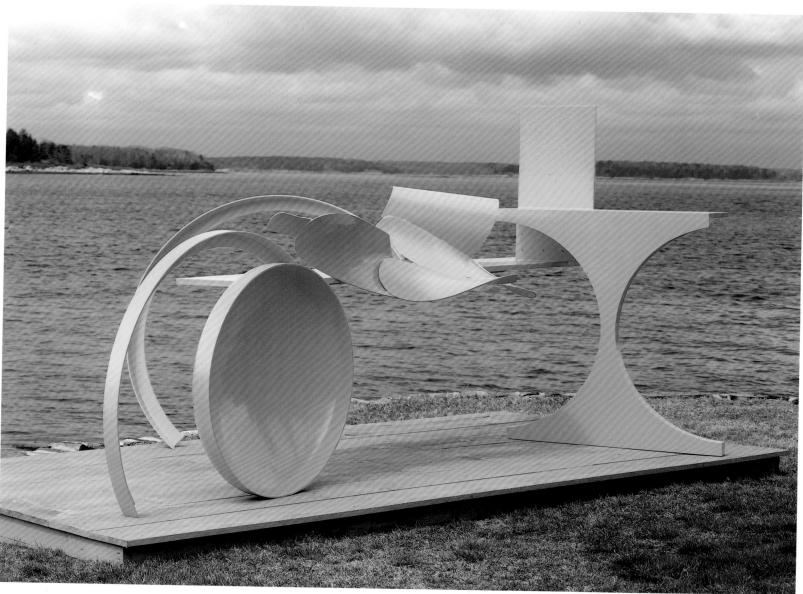

75. SUNFEAST 1969/70

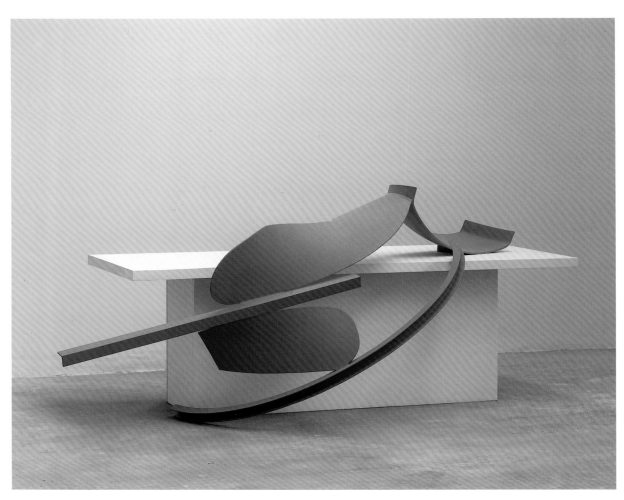

76. LAP 1969

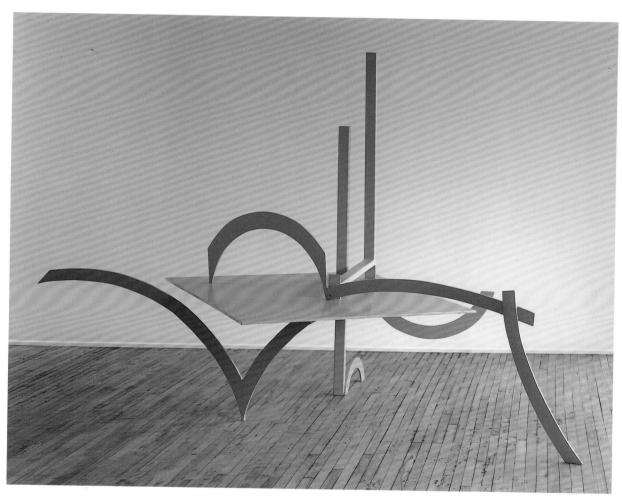

77. TREFOIL 1968

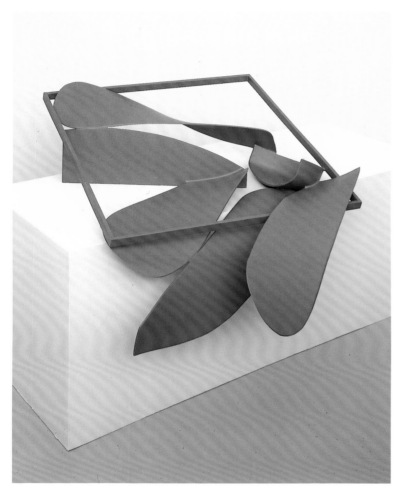

78. TABLE PIECE XCVII 1970

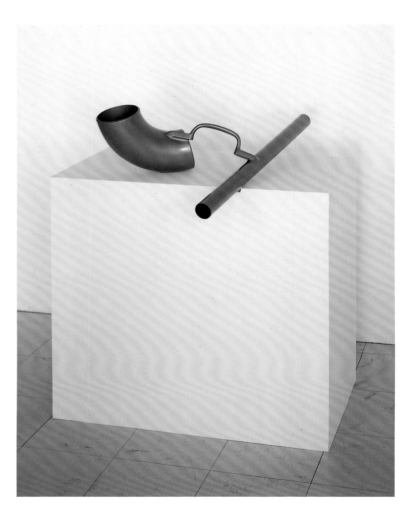

79. TABLE PIECE XXII 1967

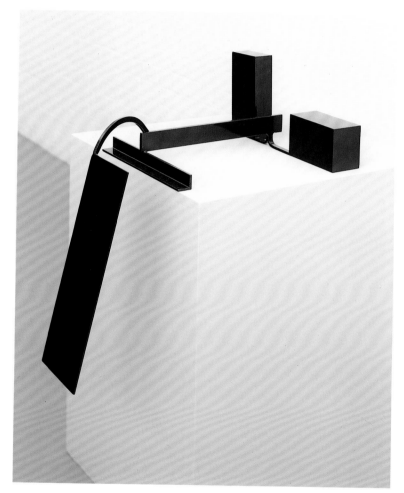

80. TABLE PIECE XLII 1967

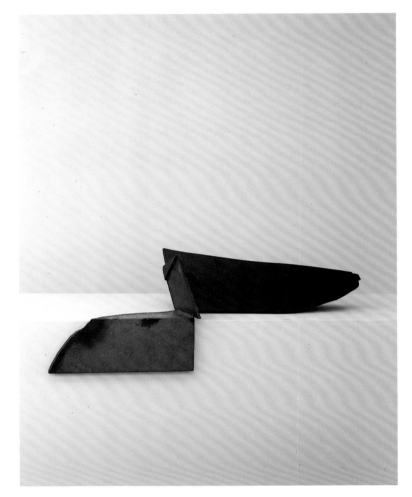

81. TABLE PIECE CLXII 1973

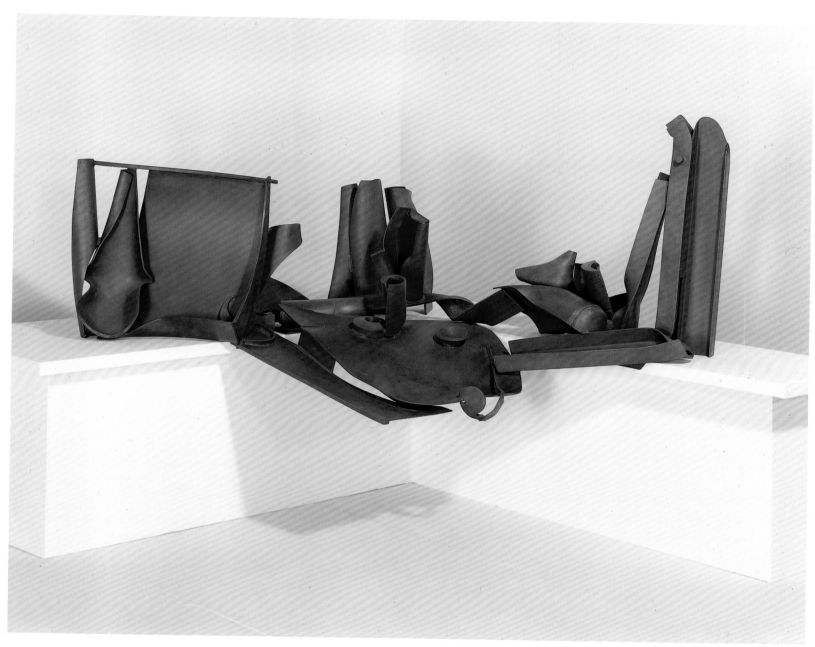

82. DEJEUNER SUR L'HERBE I 1989

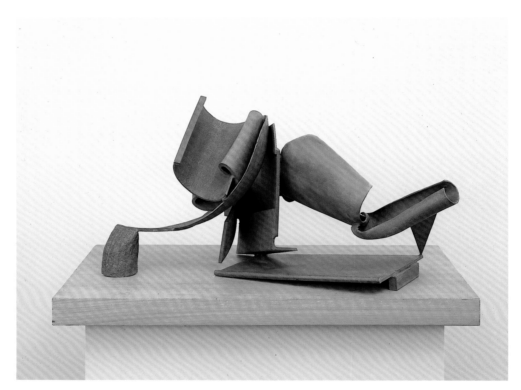

83. TABLE PIECE 'ANGEL HAIR' 1985/86

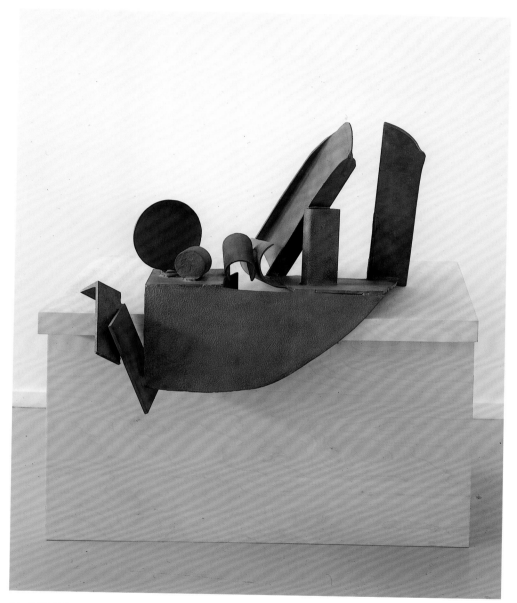

84. TABLE PIECE Y-49 'AFTER PICASSO' 1985

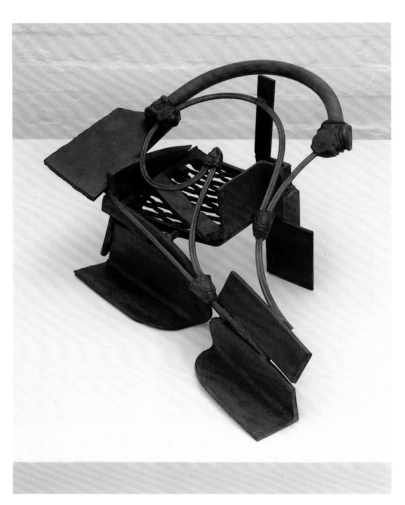

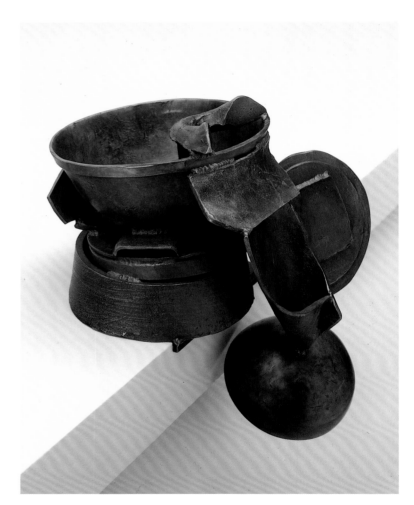

85. TABLE PIECE CCXXXII 'ROSETTE' 1976/77

86. SUMMER BIRD 1988/90

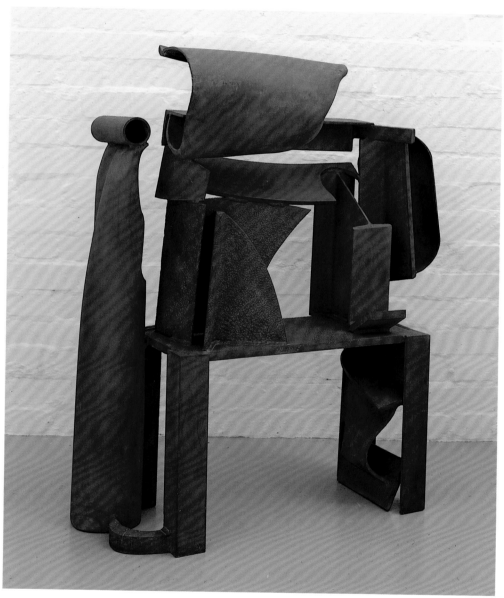

87. EGYPTIAN CHAIR 1986/87

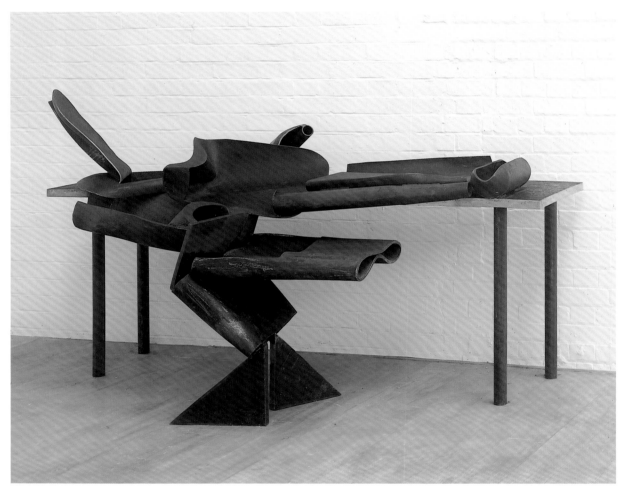

88. SUMMER TABLE 1990

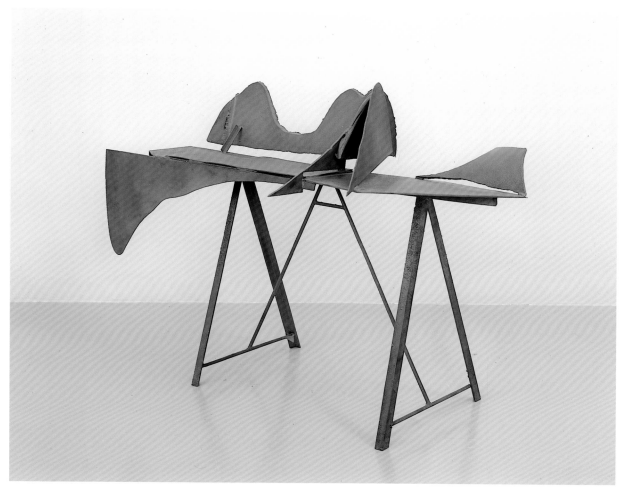

89. RIPAMONTE 1973/75

OPENINGS

FROM ANTIQUITY until the first quarter of the twentieth century, sculptors conceived their works as monoliths. Whether carved, modelled or cast, statues were solid forms that excluded everything around them. Their eloquence depended on the articulation of unbroken volumes and the inflection of continuous surfaces. Sculpture ceased to be primarily monolithic only in the late 1920s, when Picasso and González made their pioneering constructions in metal. Modern movement architecture had already rejected the dense masonry massing of the Beaux-arts tradition in favour of light, linear steel members and thin-skinned volumes, and sculpture did the same. The open, skeletal forms of modernist construction allowed sculpture to surround chunks of space, claiming and activating it, instead of simply displacing it. Forms, instead of being solid and opaque, became visually light and 'open'.

Caro's work explores openness in many ways. Like modern movement architecture, the perimeter of his sculptures is often defined by an open outline, or the thinnest of 'skins' – the visual tension between tellingly spaced elements. Frequently, Caro's pieces include sections like the literal openings we encounter in everyday experience – doors, windows, entrances – that allow us, in reality, to pass from one space to another and, in his work, to formalise the visual passage from one part of the sculpture to another. Some of these open, outlined shapes enclose schematic, exploded 'pictures' composed of freely disposed elements, loosely and momentarily corralled. Like the floating rectangles of Hans Hofmann's paintings (which Caro knows well and admires) the elements that make up these 'pictures' seem to be in flux, in front of or behind the fictive 'picture plane', like illustrations of Hofmann's 'push-pull' dictum.

We do not simply look *at* these structures, but into them and through them. The space around them and captured by their drawing begins to seem special, charged, as unlike the ordinary gaps between ordinary objects as Caro's sculpture is from those objects.

In *The Window* (100,101), a rectangle of mesh defines one side of the sculpture, as if echoing a smaller, solid plane across the way. The interval between the two becomes palpable and the size difference between them, like a forced perspective, heightens our awareness of this pregnant void. The simultaneous likeness and unlikeness of the two rectangles becomes overwhelming. The mesh plane seems expansive, generous, airborne. It allows us to see through it, while the other plane, in some ways the most dominant element of the sculpture, is completely opaque. The mesh plane, because of its transparency, reminds us of a window, while the confronting rectangle opposite seems not only a visual barrier, but a real one. Yet as we move around the sculpture, the mesh 'closes' and becomes impenetrable to the eye, at the same time that the opaque rectangle foreshortens and occupies less space in our field of vision. We begin to think not only about passages, about moving physically or in our imagination from one space to another, but about perception, about seeing itself.

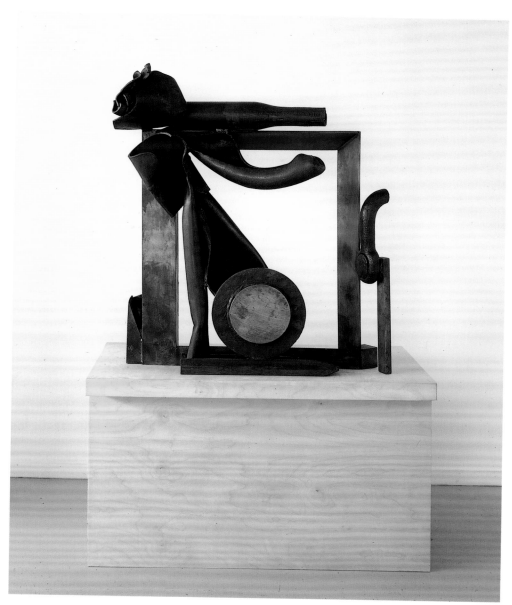

90. TABLE PIECE Y-87 'KNAVES MEASURE' 1987

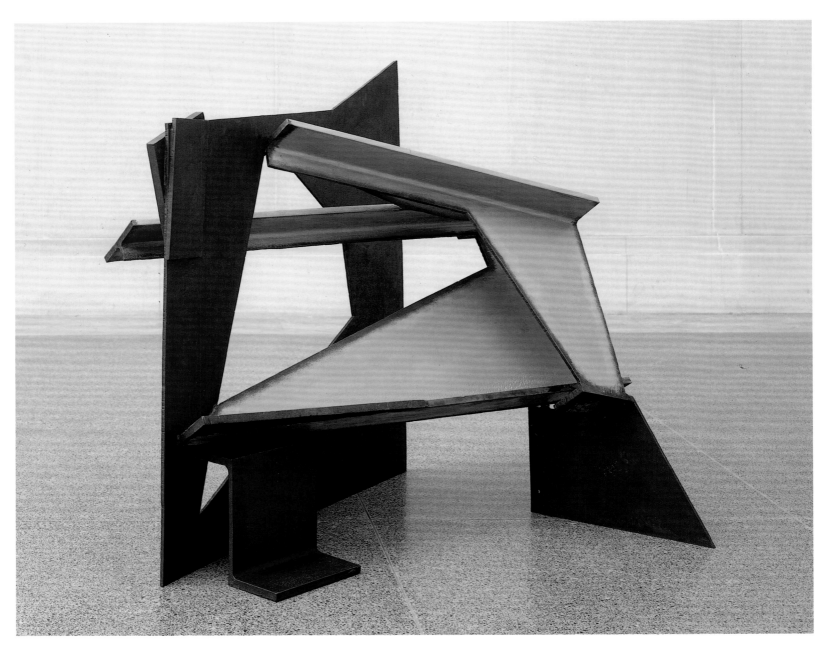

91. STRAIGHT CUT 1972

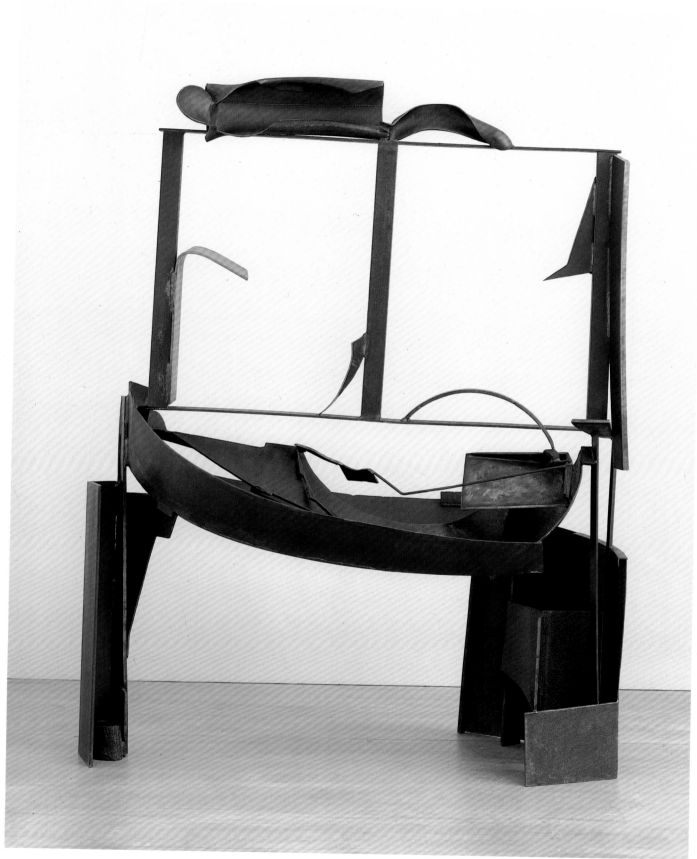

92. WINTER WINDOW 1983/87

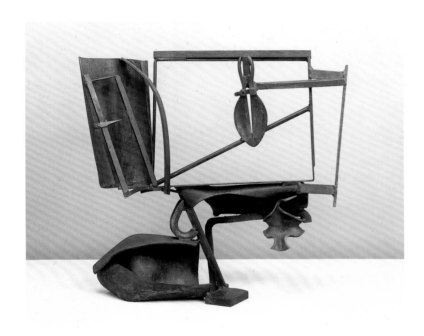

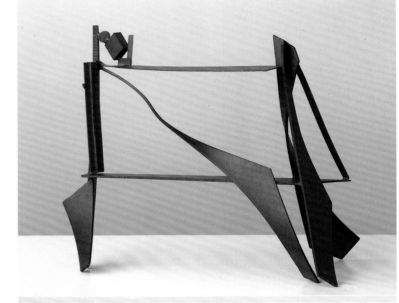

93. PICTURE OF THIS AND THAT 1988/89

94. TABLE PIECE Z-23 1980

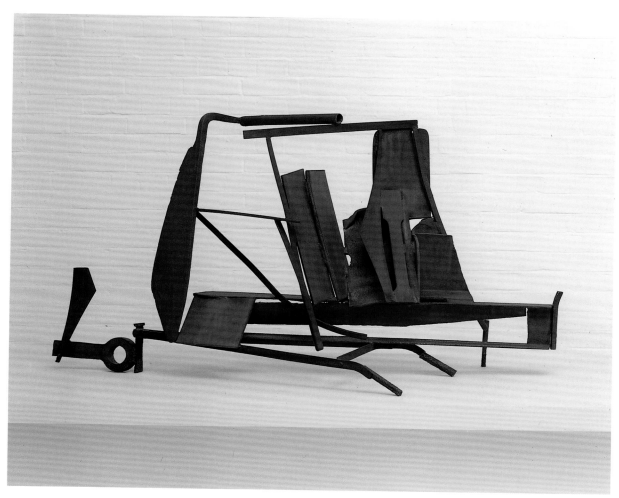

95. TABLE PIECE CCCCXIX 'BROADCAST' 1976/78

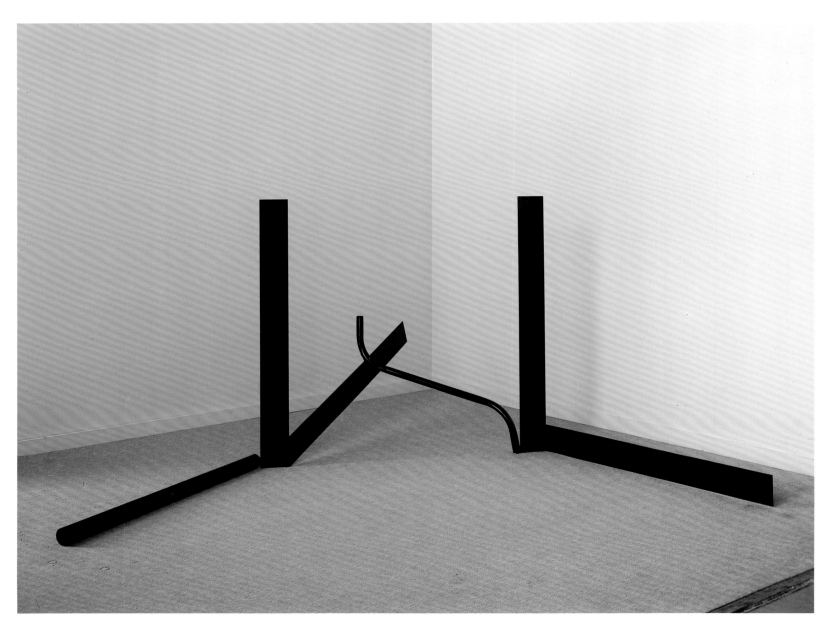

96. DEEP BODY BLUE 1967

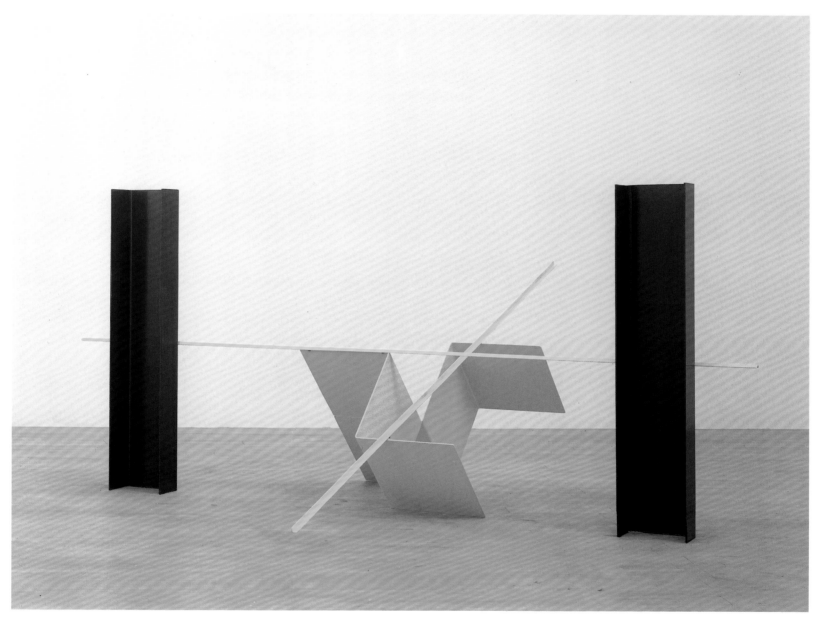

97. FIRST NATIONAL 1964

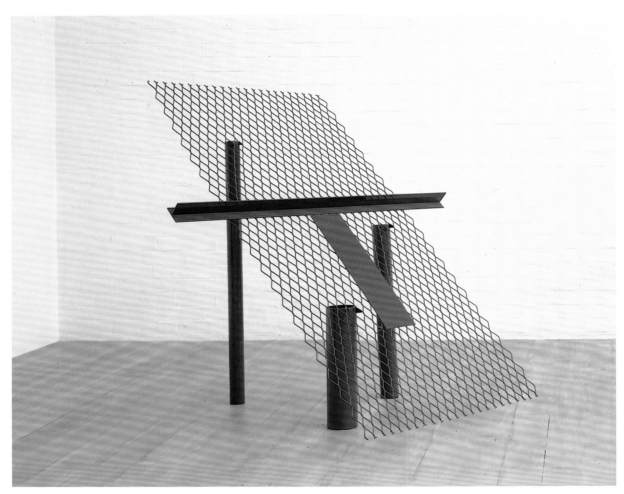

98. PARIS GREEN 1966

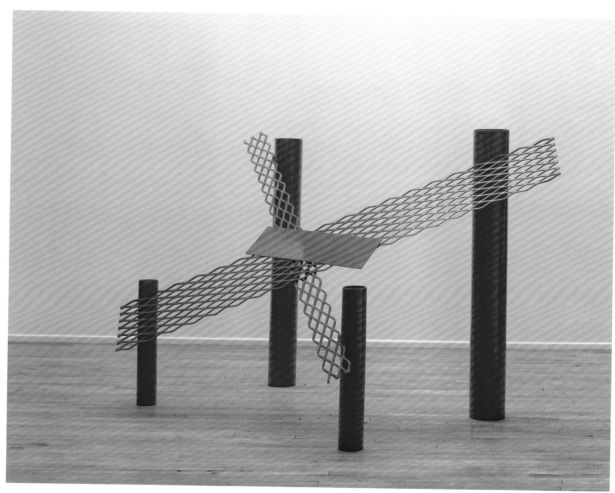

99. RED SPLASH 1966

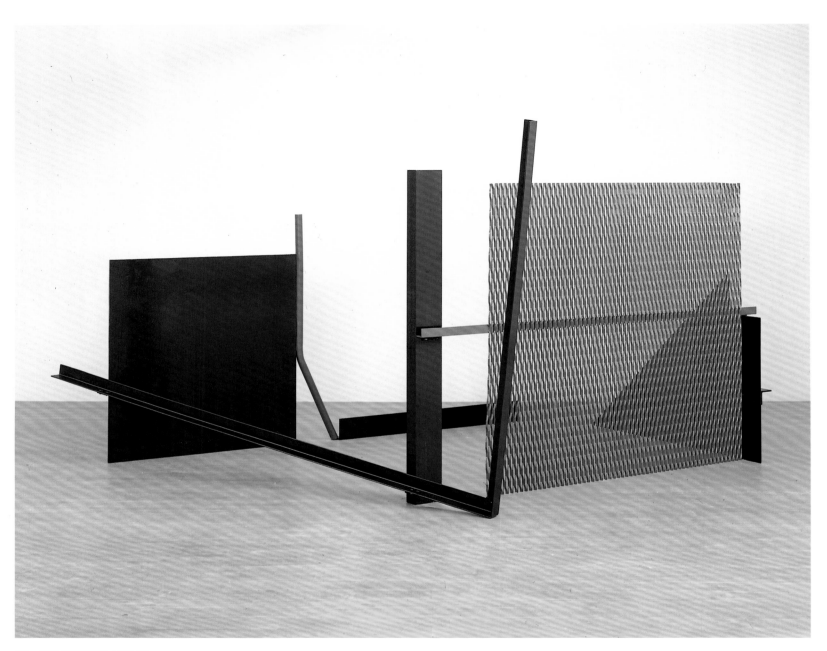

100. THE WINDOW 1966/67

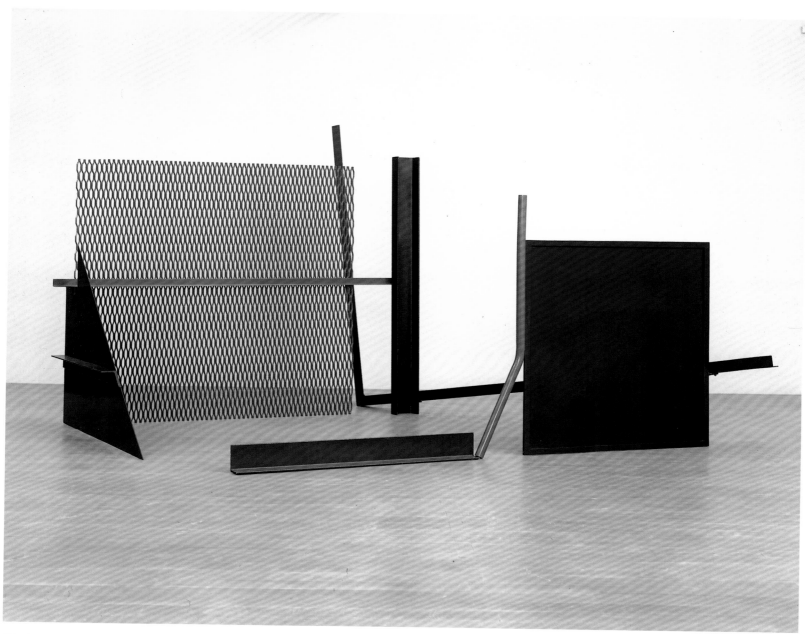

101. THE WINDOW 1966/67

PLACE

LATELY, Caro has been increasingly preoccupied by issues more usually associated with architecture than with sculpture: questions about the relation of interior and exterior, about how we perceive forms and spaces, about scale, and much more. Works like *Child's Tower Room* (102) or the half-size *Lakeside Folly* (112) are meant to be entered. Physical, not visual passage through the sculpture is necessary for full understanding. Other works, both large and small in scale, examine the broadest possible meaning of the word 'structure', adapting and transforming the familiar vocabulary of building, detaching method from context, altering size relations, and irrevocably changing the way we look at both sculpture and buildings. Some of these small sculptures make fleeting allusions to steps and entry, but other works, such as *Elephant Palace* (106), deny the possibility. Yet *Elephant Palace* is no less suggestive of interior space than any of Caro's open linear works. We perceive it as we would a building, focusing on what is before us and, at the same time, reading it for clues to what we might find inside.

The large size of many of Caro's recent works makes us rely on memory to come to terms with them, just as we must with buildings, which cannot be seen in their entirety from any one vantage point. Caro's recent work demands, more than ever, to be read sequentially, yet we cannot predict any view from the evidence offered by any other. In figurative sculpture, no matter what its scale, each view provides considerable information about the rest. No matter how inventive the piece, our knowledge of the body allows us to imagine accurately most possible views. Abstract sculpture, particularly Caro's, permits no such anticipation.

For all their size, their emphasis on volume, and their declarative structure, many of Caro's recent works resonate with associations that are not only architectural. *Xanadu* (116) and *Night Movements* (107), for example, now suggest the body, now forms in nature, now elaborate building façades, without dissolving into metaphor. In part, these multiple associations are due to their richly curved, crumpled sheets of steel, elements quite different from the geometric plates, bars, and beams of earlier sculptures. Caro's expanded vocabulary of forms claims the subtle inflections of carving and modelling for abstract construction. The active shapes and forms of *Xanadu* break and diffuse light in ways that recall Baroque art – painting, sculpture *and* architecture – minus the theatricality, plus a new heightened physicality.

What truly distinguishes these works is a quality of unignorable presentness, of self-containment that nonetheless affects everything in the vicinity, like an electric charge. Confronted by these sculptures, we do not feel that we are engaged by miniature buildings, but rather with an unprecedented reinvention of the forms, spaces, and poetry of many kinds of architecture. A host of other associations is there, as well, as powerfully as the memory of any real building, and most importantly, the force of Caro's unmistakable personality and his distinctive touch. But none of this can be described. Like all of the best art, it must be seen and experienced.

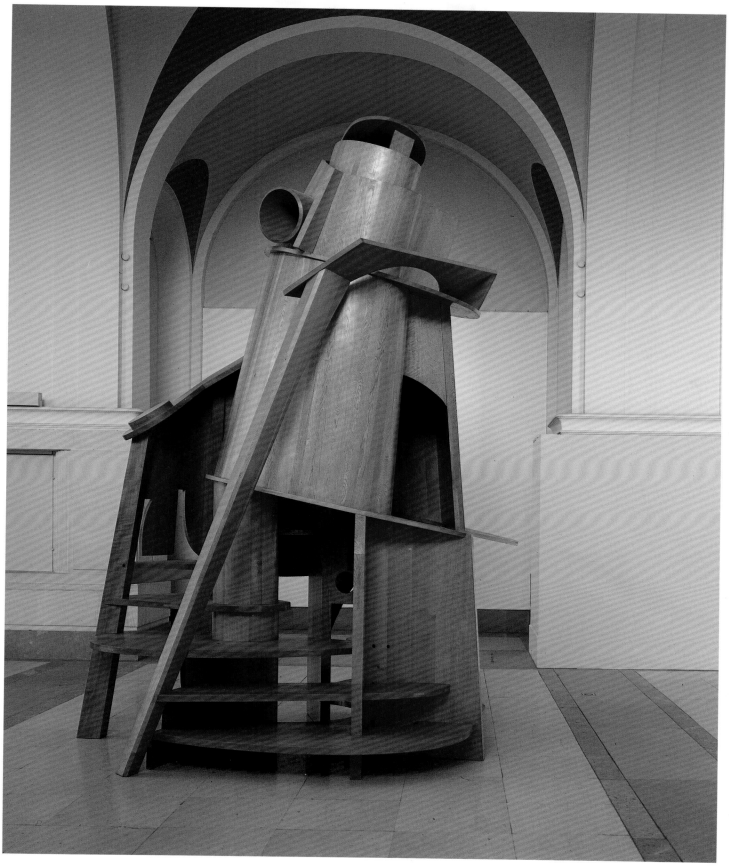

102. CHILD'S TOWER ROOM 1983/84

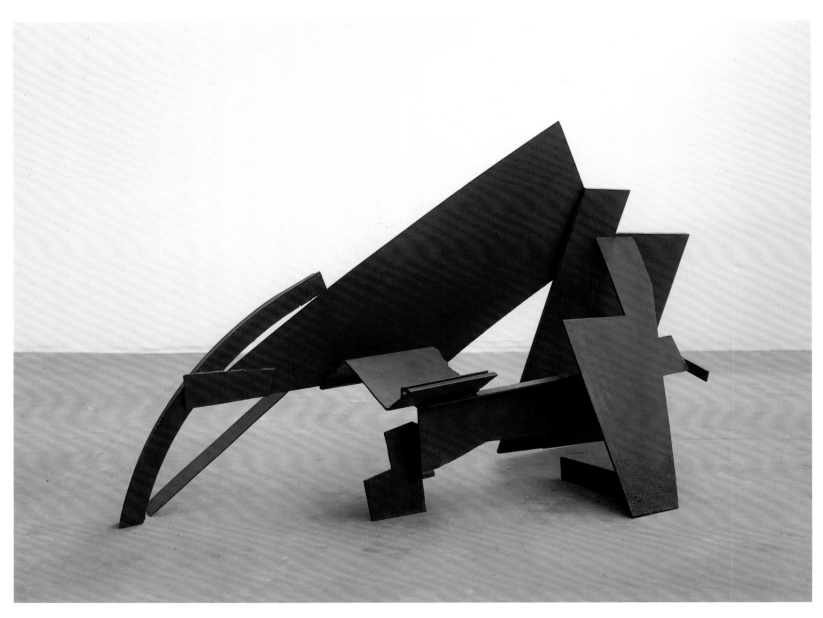

103. TRIANON 1971/72

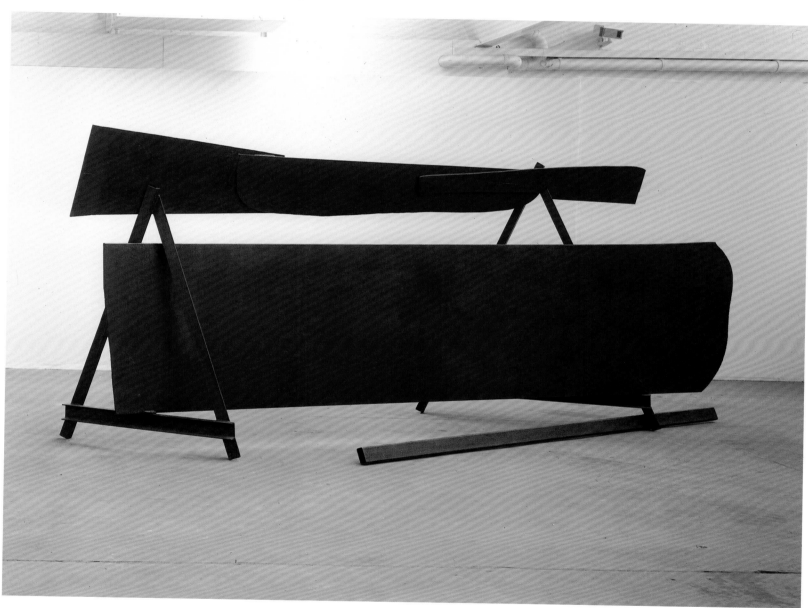

104. FATHOM 1976

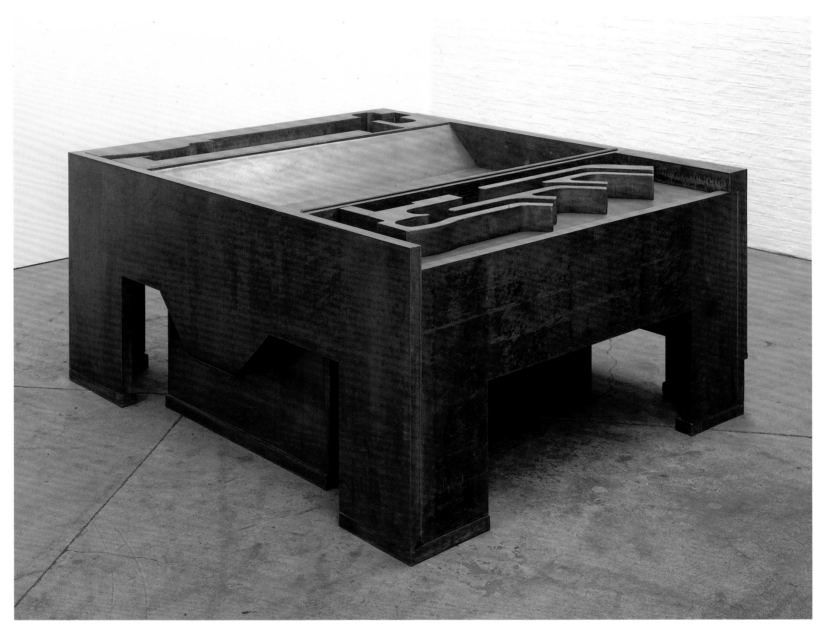

105. NIGHT AND DREAMS 1990/91

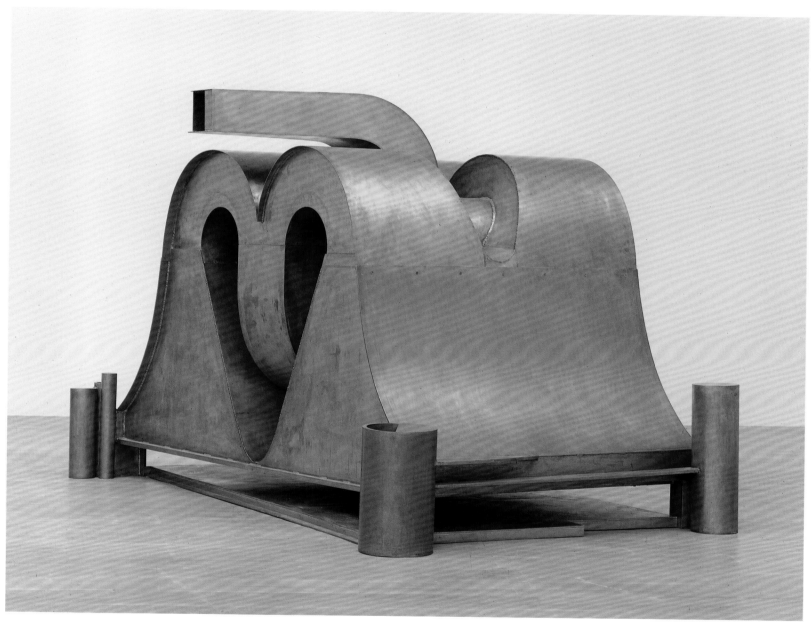

106. ELEPHANT PALACE 1989

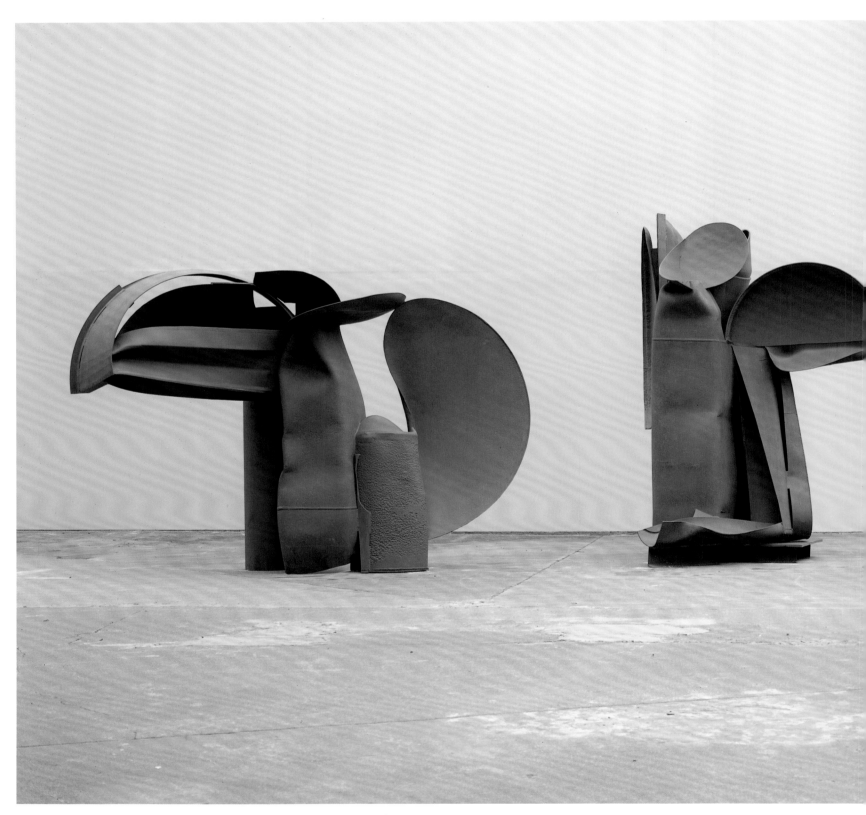

107. NIGHT MOVEMENTS 1987/90

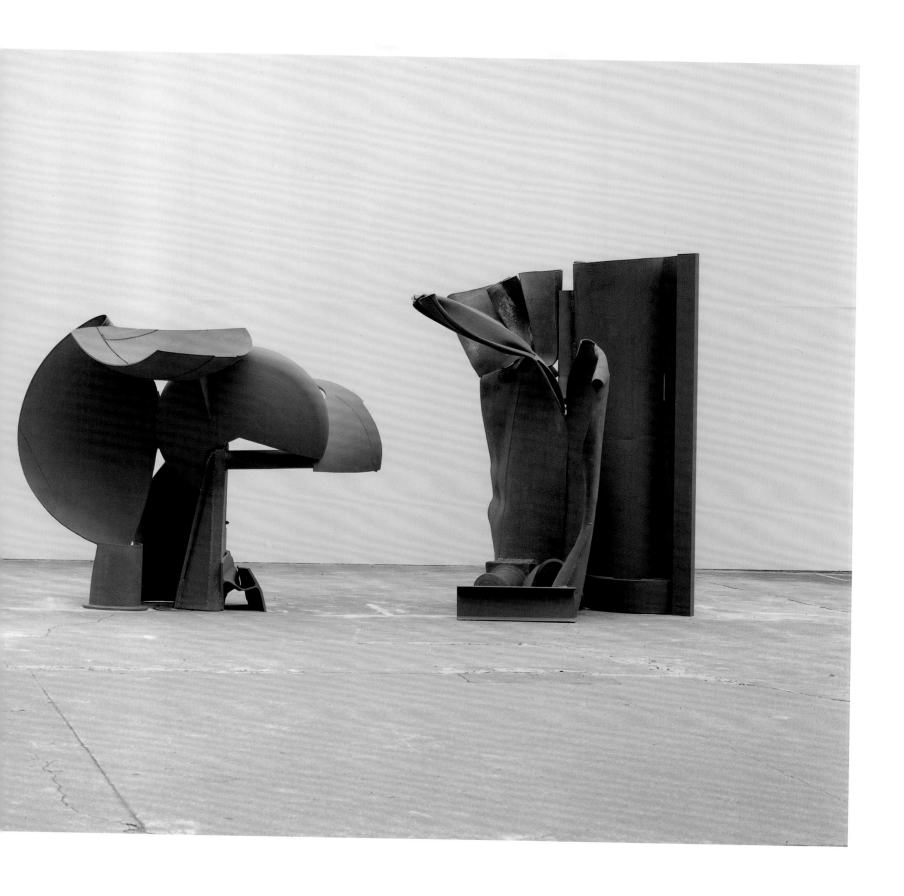

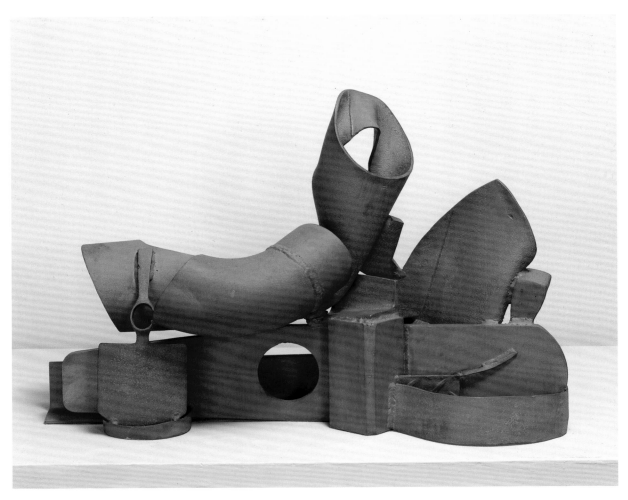

108. TABLE PIECE 'FOR RUBENS' 1988/89

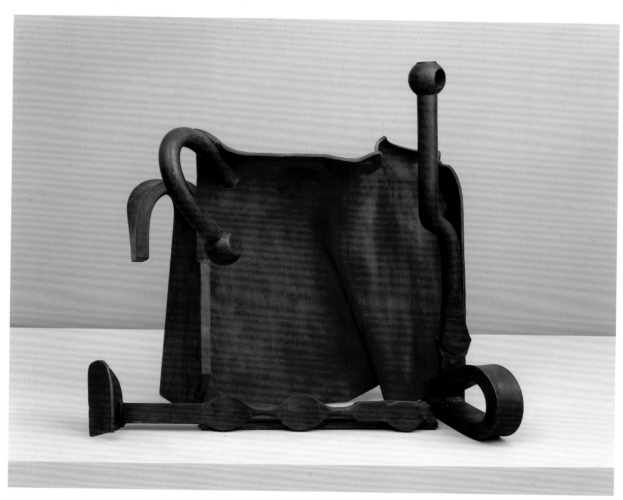

109. TABLE PIECE 'FEE-FO-FUM' 1988/89

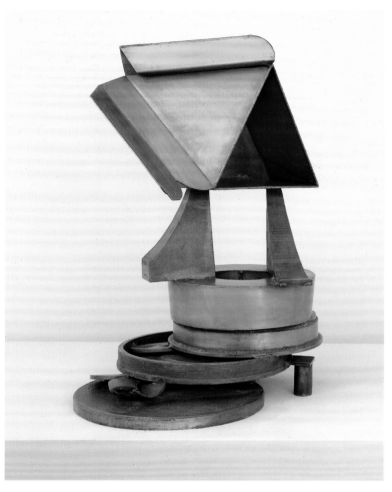

110. HIGH QUARTER 1986/87

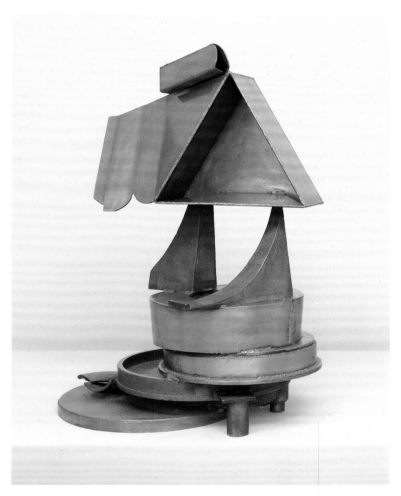

111. HIGH QUARTER 1986/87

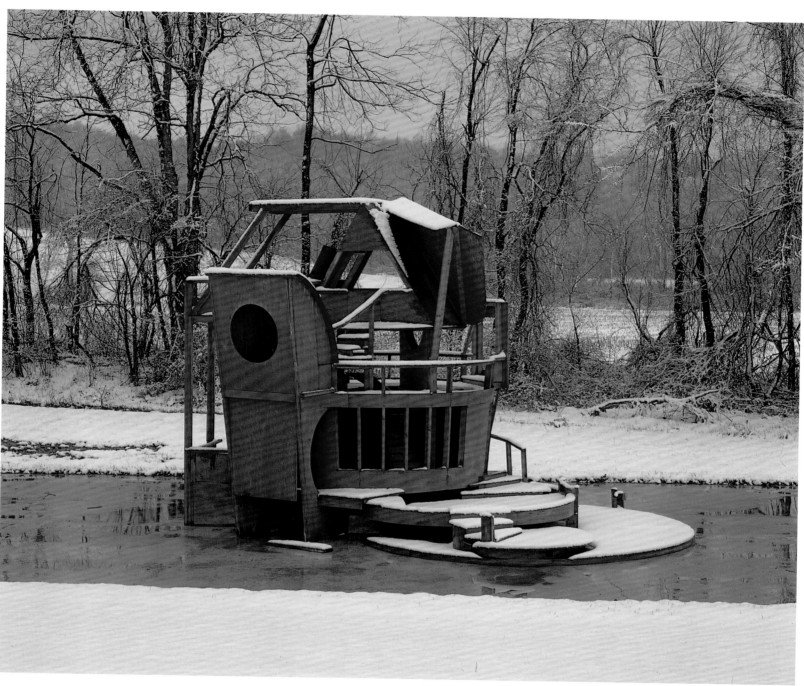

112. MODEL FOR LAKESIDE FOLLY 1988

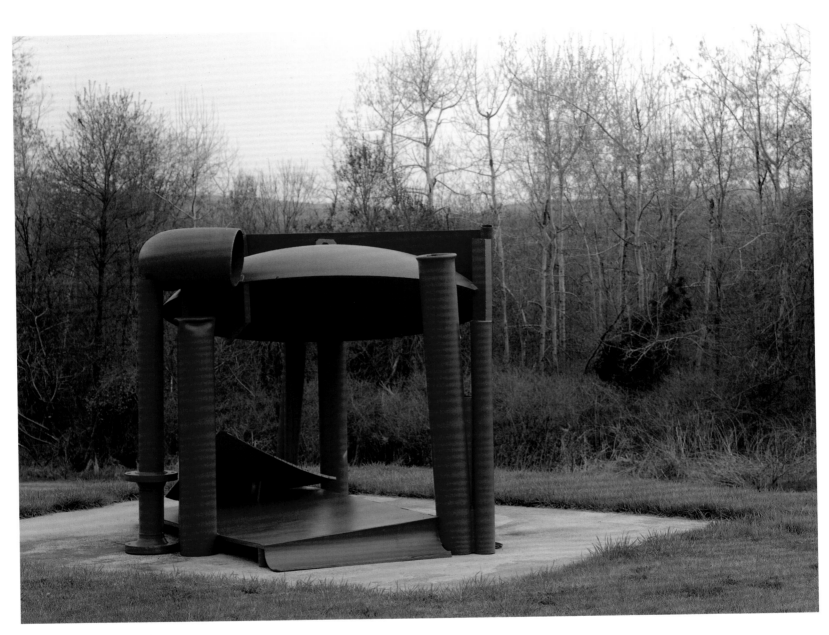

113. NORTH OF ROME 1989

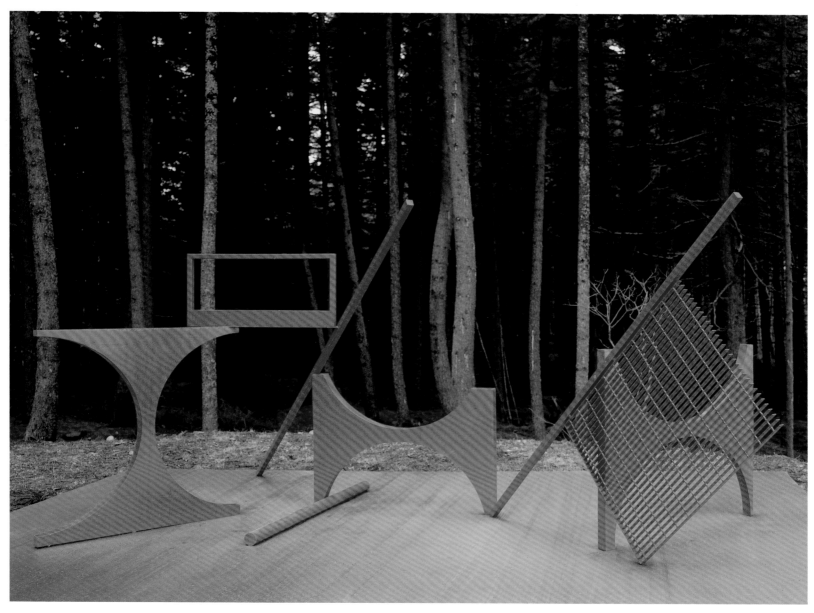

114. SPAN 1966

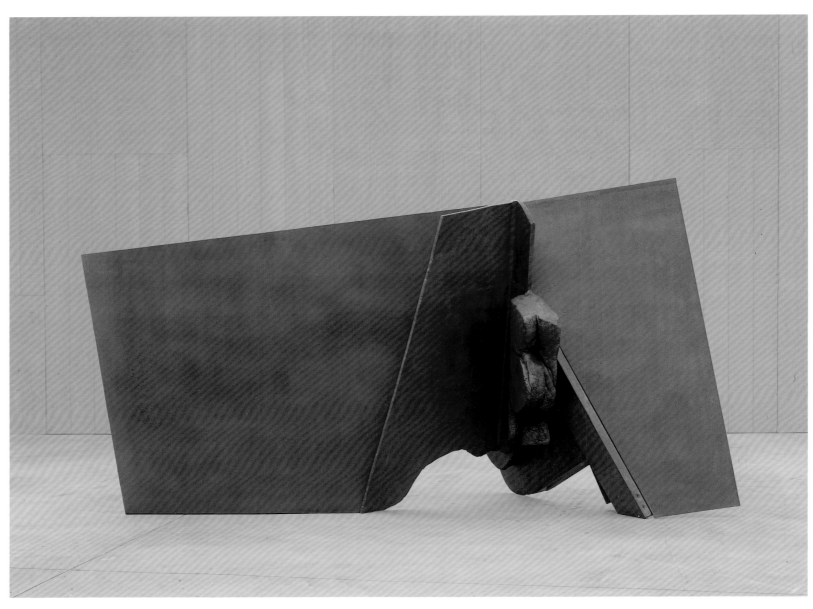

115. CLIFF SONG 1976

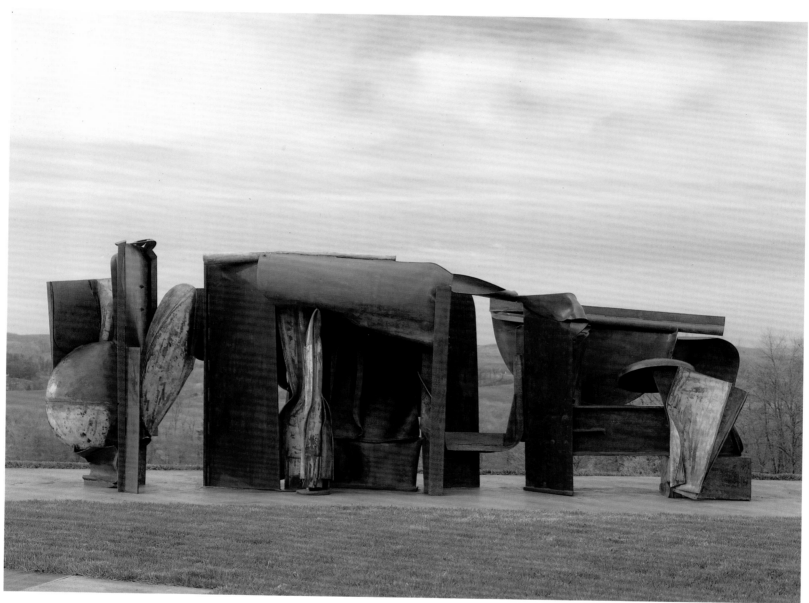

116. XANADU 1986/88

LIST
OF
PLATES

THE GROUND

1

SHAFTSBURY
1965 (847)
Steel painted purple
27 x 127 x 108 ins / 68.5 x 323 x 274.5 cm

2

SCULPTURE TWO
1962 (827)
Steel painted green
82 x 142 x 102 ins / 208.5 x 361 x 259 cm
Mr and Mrs Donald Gomme

3

LOCK
1962 (826)
Steel painted blue
34½ x 211 x 120 ins / 88 x 536 x 305 cm

4

LOW LINE FLATS
1974 (1080)
Steel rusted and varnished
52½ x 192½ x 72 ins / 133 x 489 x 183 cm
André Emmerich Gallery, New York

5

DARK MOTIVE
1971/74 (1061)
Steel rusted and varnished
63½ x 133 x 25½ ins / 161.5 x 338 x 65 cm

6

SMOULDER
1965 (857)
Steel painted purple
42 x 183 x 33 ins / 106.5 x 465 x 84 cm

7

SLOW MOVEMENT
1965 (870)
Steel painted dark blue
51 x 105 x 60 ins / 129.5 x 267 x 152.5 cm
Arts Council of Great Britain, London

8

SKIMMER FLAT
1974 (1100)
Steel rusted and varnished
69 x 247 x 48 ins / 175 x 627.5 x 122 cm
Annely Juda Fine Art, London

9

WIDE
1964 (843)
Steel and aluminium, painted burgundy
58¾ x 60 x 160 ins / 149.5 x 152.5 x 406 cm

10

THE BARRENS FLAT
1974 (1081)
Steel rusted and varnished
32 x 211 x 111 ins / 81 x 536 x 282 cm

11

DOUBLE FLATS
1974 (1092)
Steel rusted and varnished
85 x 210 x 46 ins / 216 x 533.5 x 117 cm

12

END GAME
1971/74 (1063)
Steel rusted and varnished
63½ x 174 x 47 ins / 161.5 x 442 x 119.5 cm
Mr and Mrs David Mirvish, Toronto

13

LAKE ONTARIO FLATS
1974 (1075)
Steel rusted and varnished
113 x 123 x 54 ins / 287 x 312.5 x 137 cm
Annely Juda Fine Art, London

DRAWING IN SPACE

14

EMMA DIPPER
1977 (1173)
Steel rusted and painted grey
84 x 67 x 126 ins / 213.5 x 170 x 320 cm
Tate Gallery, London

15

TABLE PIECE CCCLXXXVIII
1977 (400)
Steel rusted and varnished
40½ x 44 x 21 ins / 102.9 x 111.8 x 53.3 cm
Scottish National Gallery of Modern Art,
Edinburgh

16

TABLE PIECE CCCC (FOUR C'S)
1977/78 (416)
Steel rusted and varnished
42⅛ x 59 x 22¾ ins / 107 x 150 x 58 cm
Kunsthalle Bielefeld

17

WANDER
1965/80 (866)
Steel painted blue
98 x 277 x 81 ins / 249 x 703.5 x 206 cm

18

MONTH OF MAY
1963 (833)
Steel and aluminium, painted magenta,
orange and green
110 x 120 x 141 ins / 279.5 x 305 x 358.5 cm

19 & 20

AFTER EMMA
1977/82 (1606)
Steel rusted, blacked and painted
96 x 108 x 74 ins / 244 x 274.5 x 188 cm

21

TABLE PIECE Z-7 'EUCLID'
1978/79 (492)
Steel rusted and varnished
39 x 78 x 44 ins / 99.1 x 198.1 x 111.8 cm
Stephen Swid

22

TABLE PIECE LXXXVIII 'DELUGE'
1969 (86)
Steel painted zinc chromate primer
40 x 63 x 38 ins / 101.6 x 160 x 96.5 cm

23

WRITING PIECE 'CROSS WIND'
1988/89 (1952)
Steel rusted and painted
24 x 26 x 14½ ins / 61 x 66 x 37 cm
Fuji TV Gallery, Tokyo

24

WRITING PIECE 'CONGA'
1988/89 (1951)
Steel rusted and fixed
41 x 17 x 23 ins / 104 x 43 x 58 cm
Hakone Open Air Museum

25

TABLE PIECE CCLXVI
1975 (266)
Steel rusted and varnished
32 x 81 x 45 ins / 81.3 x 206 x 114.3 cm

26

TABLE PIECE 'CATALAN SIGNAL'
1987/88 (1839)
Steel and cast iron, blacked, rusted and fixed
33 x 26 x 12 ins / 83.5 x 66 x 30.5 cm
Acquavella Contemporary Art, New York

27

WRITING PIECE 'I'
1978/79 (552)
Steel
22½ x 10 x 17 ins / 57.2 x 25.4 x 43.2 cm
Jean Edmonson, New York

28

MEDUSA
1989 (2068)
Steel
71 x 78 x 47 ins / 180.5 x 198 x 119.5 cm
John Berggruen, San Francisco

29

TABLE PIECE 'CATALAN SCRAWL'
1987/88 (1848)
Steel rusted and fixed
41 x 40½ x 13 ins / 104 x 103 x 33 cm
Galeria Solidad Lorenzo, Madrid

30

TABLE PIECE 'CATALAN POEM'
1987/88 (1828)
Steel rusted and fixed
39 x 46 x 24 ins / 99 x 117 x 61 cm
Nabis Gallery, Seoul

31

BARCELONA BALLAD
1987 (1884)
Steel rusted and waxed
98 x 94 x 41 ins / 249 x 238.5 x 104 cm
Knoedler Gallery, London

POISE

32

MIDDAY
1960 (822)
Steel painted yellow
94½ x 38 x 144 ins / 240 x 96.5 x 366 cm
Museum of Modern Art,
Mrs Bernard F Gimbel Fund, New York

33

OVERTIME FLAT
1974/75 (1112)
Steel rusted and varnished
119 x 72 x 81 ins / 302.5 x 183 x 206 cm

34

WHISPERING
1969 (930)
Steel and wood, painted brown
117 x 61 x 35 ins / 297 x 155 x 89 cm

35

THE HORSE
1961 (823)
Steel painted dark brown
80 x 38 x 168 ins / 203.5 x 96.5 x 427 cm
Mr and Mrs David Mirvish, Toronto

36

CURTAIN ROAD
1974 (1058)
Steel rusted and varnished
78 x 188 x 109 ins / 198 x 477.5 x 277 cm

37

PIN UP FLAT
1974 (1085)
Steel rusted and varnished
79 x 103 x 67 ins / 200.5 x 261.5 x 170 cm

38

TABLE PIECE LXXV
1969 (75)
Steel sprayed matt tan
11½ x 39 x 28 ins / 29.2 x 99.1 x 71.1 cm

39

TABLE PIECE VIII
1966 (8)
Steel polished
27 x 13 x 20 ins / 68.5 x 33 x 50.8 cm

40

TABLE PIECE CLXIII
1973 (168)
Steel varnished
49½ x 33 x 20 ins / 125.7 x 83.8 x 50.8 cm
Annely Juda Fine Art, London

41

TABLE PIECE Z-85 'TIPTOE'
1982 (1264)
Steel rusted and varnished
34½ x 43 x 25 ins / 87.5 x 109 x 63.5 cm
Glasgow City Museum and Art Gallery

42

DEJEUNER SUR L'HERBE II
1989 (1931)
Steel rusted and fixed
32½ x 110½ x 73 ins / 82.5 x 280.5 x 185.5 cm

43

TABLE PIECE 'BREEZE'
1988/89 (1943)
Steel rusted and fixed
47 x 22 x 23½ ins / 119.5 x 56 x 59.5 cm

44

WRITING PIECE 'STANDARD'
1988/89 (1961)
Steel rusted and waxed
31 x 11 x 10½ ins / 79 x 28 x 26.5 cm
Nabis Gallery, Seoul

45

TABLE PIECE 'CATALAN MAID'
1987/88 (1825)
Steel rusted and fixed
53 x 27 x 15½ ins / 134.5 x 68.5 x 39.5 cm

46

TABLE PIECE LXIV 'THE CLOCK'
1968 (64)
Steel painted zinc chromate primer
30 x 51 x 32 ins / 76.2 x 129.5 x 81.3 cm

47

TABLE PIECE VII
1966 (7)
Steel polished
23 x 3¾ x 14 ins / 58.4 x 9.5 x 35.6 cm

48

TABLE PIECE XVIII
1967 (18)
Steel polished and lacquered
10 x 21 x 20 ins / 25.4 x 53.3 x 50.8 cm
Kenneth Noland

49

PITCH
1967 (902)
Steel painted charcoal
115 x 62 x 9 ins / 292 x 157.5 x 23 cm

50

EARLY ONE MORNING
1962 (830)
Steel and aluminium, painted red
114 x 244 x 131 ins / 290 x 620 x 333 cm
Tate Gallery, London

LEVELS

51
ORANGERIE
1969 (929)
Steel painted red
88½ x 64 x 91 ins / 225 x 162.5 x 231 cm
Kenneth Noland

52
TABLE PIECE L
1968 (50)
Steel painted grey
19 x 21⅛ x 34 ins / 48.3 x 53.6 x 86.4 cm

53
TABLE PIECE LXXX
1969 (79)
Steel painted deep blue
13½ x 53 x 20 ins / 34.3 x 134.6 x 50.8 cm

54
HOP SCOTCH
1962 (829)
Aluminium
98½ x 84 x 187 ins / 250 x 213.5 x 475 cm

55
TEMPUS
1970 (961)
Steel painted green
45 x 46½ x 47 ins / 114.5 x 118 x 119.5 cm

56
ICE HOUSE
1977/78 (686)
Bronze cast and welded
31½ x 38 x 32 ins / 80 x 96.5 x 81.3 cm
Galeria Joan Prats, Barcelona

57
TABLE PIECE Z-44
1979/81 (1214)
Steel rusted and varnished
32 x 28 x 19 ins / 81.5 x 71 x 48.5 cm
Rahel and Dov Guttesman

58
LADDER SONG
1988/89 (1934)
Steel rusted and waxed
38½ x 21½ x 14½ ins / 97.5 x 54.5 x 37 cm
Judith and Edward Neisser

59
SUN-GATE
1986/88 (1914)
Steel rusted and varnished
91 x 115 x 36 ins / 231 x 292 x 91.5 cm

60
TANTUM
1970 (942)
Steel painted green
47 x 34 x 44 ins / 119.5 x 86.5 x 112 cm

61
SCULPTURE SEVEN
1961 (825)
Steel painted green, blue and brown
70 x 211½ x 41½ ins / 178 x 537 x 105.5 cm

62
EMMA BOOKS
1977/78 (1181)
Steel rusted and varnished
63 x 52 x 24 ins / 160 x 132 x 61 cm
André Emmerich Gallery, New York

63
ORDNANCE
1971 (995)
Steel rusted and varnished
51 x 76 x 143 ins / 129.5 x 193 x 363 cm

VESSELS

64
NORTHERN VESSEL
1989
Steel rusted and waxed
43 x 54 x 20 ins / 109 x 137 x 51 cm
Annely Juda Fine Art, London

65
CHEMICAL BOX
1987 (1875)
Bronze cast and welded, and brass
24½ x 24 x 17 ins / 62 x 61 x 43 cm
Flemming Frahm

66
LATE QUARTER (VARIATION G)
1981 (1578)
Bronze cast and welded, and brass
14½ x 23 x 18 ins / 37 x 58.5 x 45.5 cm
Ann Marie and Patrick Cunningham, London

67
CAMPANELLA
1983 (1561)
Bronze cast and welded, and brass
16½ x 31 x 23 ins / 42 x 79 x 58.5 cm
Richard Gray Gallery, Chicago

68
ANGEL BAY
1984 (1771)
Steel varnished
80 x 80 x 60 ins / 203 x 203 x 152.5 cm

69
TABLE PIECE 'CATALAN ROLL'
1987/88 (1844)
Steel rusted and waxed
28 x 45 x 20 ins / 71 x 114.5 x 51 cm

THE TABLE

70

TABLE PIECE 'CROOK'
1988/89 (1947)
Steel rusted and waxed
37½ x 25 x 18 ins / 95 x 64 x 46 cm
Forum Fine Art, Jacqueline Krotoschin,
Zurich

71

HALF MOON
1980 (809)
Bronze cast and welded and brass
28½ x 31 x 20½ ins / 72.4 x 78.7 x 52.1 cm
Arts Council of Great Britain, London

72

BLACK RUSSIAN
1984/85 (1793)
Steel, painted red and dark green
92 x 64 x 69 ins / 233.5 x 162.5 x 175 cm
Annely Juda Fine Art, London

73

TABLE PIECE 'HELM'
1988/89 (1960)
Steel and steel sheet rusted
24 x 25 x 18 ins / 61 x 63.5 x 46 cm
Galerie Lelong, Paris

74

FOSSIL FLATS
1974 (1082)
Steel rusted and varnished
73 x 53 x 86 ins / 185.5 x 134.5 x 218.5 cm
Knoedler Gallery, London

75

SUNFEAST
1969/70 (933)
Steel painted yellow
71½ x 164 x 86 ins / 181.5 x 416.5 x 218.5 cm

76

LAP
1969 (928)
Steel painted matt yellow
43 x 60 x 96 ins / 109 x 152.5 x 244 cm

77

TREFOIL
1968 (920)
Steel painted matt yellow
83 x 100 x 65 ins / 211 x 254 x 165 cm
Mr and Mrs David Mirvish, Toronto

78

TABLE PIECE XCVII
1970 (95)
Steel painted tan
25 x 53 x 44 ins / 63.5 x 134.6 x 111.8 cm

79

TABLE PIECE XXII
1967 (22)
Steel sprayed jewelscent green
10 x 31½ x 27 ins / 25.4 x 80 x 68.6 cm

80

TABLE PIECE XLII
1967 (42)
Polished steel sprayed green
23½ x 15½ x 29 ins / 59.7 x 39.4 x 73.7 cm

81

TABLE PIECE CLXII
1973 (167)
Steel varnished
17 x 52 x 18½ ins / 43.2 x 132.1 x 47 cm

82

DEJEUNER SUR L'HERBE I
1989 (1930)
Steel rusted and waxed
51 x 102 x 68 ins / 130 x 259 x 173 cm
Galerie Hans Mayer, Dusseldorf

83

TABLE PIECE Y-61
'ANGEL HAIR'
1985/86 (1686)
Steel varnished and waxed
21 x 39½ x 19 ins / 53.5 x 100.5 x 48 cm

84

TABLE PIECE Y-49
'AFTER PICASSO'
1985 (1673)
Steel rusted and waxed
31½ x 37 x 31 ins / 80 x 94 x 78.5 cm
Sherry Stuart Christhils III, Baltimore

85

TABLE PIECE CCXXXII 'ROSETTE'
1976/77 (340)
Steel and cast iron rusted and varnished
13 x 28 x 22 ins / 33 x 71.1 x 55.9 cm

86

SUMMER BIRD
1988/90 (2013)
Brass and bronze cast and welded
17 x 12½ x 13 ins / 43 x 32 x 33 cm
Galerie Wentzel, Köln

OPENINGS

87

EGYPTIAN CHAIR
1986/87 (1905)
Steel rusted and varnished
40 x 32 x 15 ins / 101.5 x 81 x 38 cm
Sandie and Ian Barker, London

88

SUMMER TABLE
1990 (1977)
Steel rusted and waxed
47½ x 83 x 42 ins / 121 x 211 x 107 cm
Annely Juda Fine Art, London

89

RIPAMONTE
1973/75 (1043)
Steel rusted and varnished
44 x 73 x 22 ins / 112 x 185.5 x 56 cm

90

TABLE PIECE Y-87
'KNAVES MEASURE'
1987 (1817)
Steel waxed
46½ x 39 x 16 ins / 118 x 99 x 40.5 cm
John Usdan, Westport

91

STRAIGHT CUT
1972 (1015)
Steel rusted and painted silver
52 x 62 x 51 ins / 132 x 157.5 x 129.5 cm
The Earl of Crawford

92

WINTER WINDOW
1983/87 (1911)
Steel varnished
74 x 56 x 26½ ins / 188 x 142 x 67.5 cm
Fabian Carlsson

93

PICTURE OF THIS AND THAT
1988/89 (1939)
Steel rusted and waxed
27 x 26 x 11 ins / 68 x 66 x 28 cm
Galeria Juana Mordo, Madrid

94

TABLE PIECE Z-23
1980 (572)
Steel rusted and varnished
·32½ x 37½ x 22 ins / 82.6 x 95.3 x 55.9 cm
Constantine Grimaldis Gallery, Baltimore

95

TABLE PIECE CCCCXIX
'BROADCAST'
1976/78 (446)
Steel rusted and varnished
34½ x 66 x 27 ins / 87.6 x 167.6 x 68.6 cm

96

DEEP BODY BLUE
1967 (908)
Steel painted stark blue
58½ x 101 x 124 ins / 149 x 256.5 x 315 cm

97

FIRST NATIONAL
1964 (835)
Steel painted green and yellow
110 x 120 x 141 ins / 279.5 x 305 x 358 cm

98

PARIS GREEN
1966 (878)
Steel and aluminium, painted green
53 x 54½ x 56 ins / 134.5 x 138.5 x 142 cm

99

RED SPLASH
1966 (879)
Steel painted red
45½ x 69 x 41 ins / 115.5 x 175.5 x 104 cm
Mr and Mrs David Mirvish, Toronto

100 & 101

THE WINDOW
1966/67 (903)
Steel painted green and olive green
84¾ x 126¼ x 153½ ins / 215 x 320.5 x 390 cm

PLACE

102

CHILD'S TOWER ROOM
1983/84 (1719)
Japanese Oak, varnished
150 x 108 x 108 ins / 381 x 274.5 x 274.5 cm

103

TRIANON
1971/72 (1021)
Steel varnished
63 x 42 x 103 ins / 160 x 107 x 261.5 cm

104

FATHOM
1976 (1126)
Steel rusted and varnished
81 x 305 x 66 ins / 206 x 775 x 167.5 cm

105

NIGHT AND DREAMS
1990/91
Steel waxed
41 x 88 x 74 ins / 104 x 224 x 188 cm
Annely Juda Fine Art, London

106

ELEPHANT PALACE
1989 (2051)
Brass
74 x 119½ x 75 ins / 188 x 304 x 190 cm
Annely Juda Fine Art, London

107

NIGHT MOVEMENTS
1987/90 (2072)
Steel stained green, varnished and waxed
108½ x 424 x 132 ins / 276 x 1077 x 335 cm
Annely Jude Fine Art, London / Galerie
Lelong, Paris

108

TABLE PIECE 'FOR RUBENS'
1988/89 (1964)
Steel rusted and waxed
20½ x 32 x 11 ins / 52 x 81 x 28 cm
Galerie Lelong, Paris

109

TABLE PIECE 'FEE-FO-FUM'
1988/89 (1942)
Steel rusted and waxed
29½ x 32½ x 16 ins / 75 x 83 x 40.5 cm
Galerie Lelong, Paris

110 & 111

HIGH QUARTER
1986/87 (1863)
Bronze cast and welded
38 x 26 x 20¼ ins / 96.5 x 66 x 51.5 cm

112

MODEL FOR LAKESIDE FOLLY
1988 (1858)
Plywood, painted red
181 x 260 x 178 ins / 460 x 660.5 x 452 cm

113

NORTH OF ROME
1989 (2063)
Steel, painted dark red rustoleum
91½ x 102 x 140 ins / 232.5 x 259 x 355.5 cm
Gallery Kasahara, Osaka

114

SPAN
1966 (898)
Steel painted burgundy
77½ x 184 x 132 ins / 197 x 468 x 335.5 cm

115

CLIFF SONG
1976 (1142)
Steel rusted and varnished
77½ x 139 x 51 ins / 197 x 353 x 129.5 cm

116

XANADU
1986/88 (1915)
Steel waxed
94½ x 245 x 64 ins / 240 x 622.5 x 162.5 cm

CHRONOLOGY

1924
Born 8 March, New Malden, Surrey, son of Alfred and Mary Caro.
His father was a stockbroker, both families came from Norwich.

1937-42
Charterhouse School, Godalming, Surrey.
During vacations worked in studio of the sculptor Charles Wheeler.

1942-4
Studied engineering at Christ's College, Cambridge.

1944-6
Fleet Air Arm of Royal Navy.
When on leave attended Farnham School of Art.

1946-7
Regent Street Polytechnic, London: studied sculpture under
Geoffrey Deeley.

1947-52
Royal Academy Schools, London: was taught at first on a termly basis by
different sculptor academicians (MacWilliam, Hardiman,
Charoux etc). Later Maurice Lambert was appointed head of sculpture.
Received various medals for academic sculpture in clay.

1949
Married the painter Sheila Girling: two sons Timothy (1951) and Paul
(1958).

1951-3
Worked as part-time assistant to Henry Moore.
Early work influenced by Moore and by Negro sculpture, later by
Picasso.

1953-79
Taught two days a week at St Martin's School of Art, London.

1955
Exhibited two figurative sculptures at 'New Painters and Painters-
Sculptors', Institute of Contemporary Arts, London.

1956
First one-man exhibition: Galleria del Naviglio, Milan.
The sculptures shown are distorted figures and heads modelled in clay
or plaster.

1957
First one-man show in London: Gimpel Fils Gallery.

1959
Won the sculpture prize at the first Paris Biennale.
Work showed influence of de Kooning, Dubuffet and Bacon.
Met Clement Greenberg in London: subsequent conversations and
studio visits were a great influence on Caro's approach and attitude
to art.
Visited USA for the first time: met Kenneth Noland and David Smith.

1960
On return to London made first abstract sculptures.
Visited Carnac, Brittany. Studied the primitive menhirs and dolmens.
Caro's early steel sculptures were influenced by their sense of presence.

1963
Major one-man exhibition of abstract steel sculptures at Whitechapel
Gallery, London.

1963-5
Taught at Bennington College, Bennington, Vermont.
Furthered contact with Noland, Olitski and Smith who lived nearby.
Noland suggested Caro work in series, a procedure which he has often
used since then.

1964
First one-man exhibition in New York: André Emmerich Gallery
(annual or biannual exhibitions thereafter).
From this point on Caro visited and worked in USA for a month or two
each year.
Charlie Hendy joined Caro as his technical assistant.

1966
Exhibited as one of 'Five Young British Artists', British Pavilion,
Venice Biennale (with painters Richard Smith, Harold Cohen, Bernard
Cohen and Robyn Denny).
Awarded David E Bright Foundation Prize.
After discussions with Michael Fried began first table sculptures.

1967
Retrospective exhibition at Rijksmuseum Kröller-Müller, Otterlo,
Holland.

1969
Exhibited, with John Hoyland, in British Section of X São Paulo
Biennale.
Pat Cunningham became Caro's principal assistant in his London
studio.
Retrospective exhibition at Hayward Gallery, London.
Appointed Commander of the Order of the British Empire.

CHRONOLOGY

(Continued from previous page)

1970
Began making sculptures which were left unpainted, the rusted steel
simply varnished or waxed instead.

1971
Travelled to Mexico, New Zealand, Australia and India.

1972
Made fourteen sculptures using roll steel ends at Ripamonte factory,
Veduggio, Brianza, Italy.
Despite the language difficulties, this experience of working in a
factory led to many other short but intense periods of workshop
sculpture-making in other countries.

1974
Worked at York Steel Co. factory in Toronto and made thirty-seven
large sculptures assisted by sculptors James Wolfe and
Willard Beopple. He returned several times over the next two years to
finally complete these sculptures.

1975
Retrospective exhibition at Museum of Modern Art, New York (which
travelled to Walker Art Center, Minneapolis; Museum of Fine Art,
Houston; and Museum of Fine Art, Boston).
Worked in ceramic clay at workshop at Syracuse University, New York
organised by Margie Hughto.
Experience of working with clay led to the use of bronze castings
welded directly to plate brass and bronze in his sculpture.

1976
Presented with key to the City of New York by Mayor Abraham Beame.

1977
Retrospective exhibition of table sculptures at Tel Aviv Museum
organised by the British Council (later toured Australia,
New Zealand and Germany).
Artist in residence at Emma Lake summer workshop, University of
Saskatchewan. Using tubular steel, worked in a linear mode.

1978
Executed commission for East Wing of the National Gallery in
Washington DC.
Made first 'writing pieces': small calligraphic sculptures in steel.
These small pieces often include tools or other utensils.

1979
Received Honorary Doctorates from University of East Anglia and York
University, Toronto.

1982
Appointed Trustee of Tate Gallery, London.
Initiated, together with Robert Loder, the Triangle Workshop for
sculptors and painters at Pine Plains, New York, held annually
thereafter.

1984
One-man exhibition at Serpentine Gallery, London, which travelled
to Copenhagen, Dusseldorf and Barcelona.
Created the 'Child's Tower Room' for 'Four Rooms' exhibition at
Liberty's, London. This was the first sculpture which involved
architecture where the spectator was invited to enter the sculpture
and experience its inner space.

1985
Led sculptors' workshop, Maastricht, Holland.
Made an Honorary Doctor of Letters, Cambridge University.
Visited Greece for the first time.
Built a barn at Ancram, New York State, which he then used as his
USA studio. Jon Isherwood became Caro's assistant there.

1987
Attended workshops in Berlin and Barcelona.
Executed, in his London studio, 'After Olympia', his largest sculpture
to date.
Awarded knighthood, Queen's Birthday Honours.

1989-90
Attended steel workshop at University of Alberta, Edmonton, and
bronze workshop at Red Deer College, Alberta.
Exhibition 'Aspects of Anthony Caro' at Annely Juda Fine Art and
Knoedler Gallery, London.
Exhibited at Walker Hill Art Center, Seoul; visited Korea and India.
Awarded Honorary Degree, Yale University.
Visited Japan and started series of paper sculptures at Nagatani's
workshop, Obama.

1991
Awarded First Nobutaka Shikanai Prize, Hakone Open Air Museum,
Japan.
Completed two large sculptures which involve dialogue with
architecture: 'Sea Music' for the quayside, Poole, Dorset, and
'The Octagon Tower' for an exhibition of recent large sculptures at the
Tate Gallery, London.

ACKNOWLEDGEMENTS

Many people have helped in the
preparation of this volume, including
friends, owners of works and colleagues,
and particular thanks are due to:

William Acquavella · Matt Austin
Kay Bearman · Maureen Beatty
Robert Brockhouse · Sue Brown
Lewis and Susan Cabot · Richard Calvocoressi
Stephen Cockerton · Sacha Craddock
Lord and Lady Crawford
Patrick Cunningham · Gary Doherty
Jacques Dupin · Jean Edmonson
Patrick Elliott · André Emmerich
Dominique Fourcade · Jean Fremon
Francois Gaillard · Sheila Girling
Donald and Jill Gomme · Elizabeth Goodall
Constantine Grimaldis · Keith Hartley
John Hock · Jutta Hulsewig-Johnen
Jon Isherwood · Eleanor Johnson
Isobel Johnson . Trish Johnson
Annely and David Juda · John Kasmin
Natalia Lavarello · Priscilla Lee
Cedric Leefe · Daniel Lelong
William S. Lieberman · Duncan McGuigan
David Mirvish · Kenneth Noland
Lord and Lady Palumbo · Kathryn Potts
Nicola Redway · James Reilly
Julian Spalding · Anthony Smee
Helen Spender · Hugh T. Stevenson
Stephen Swid · Michael Tooby
Jordan Tuiller · John Usdan · Kirk Varnedoe
Michel Vernard · Mary Jo Waid
Brenda Ward · Richard Wood
Hanford Yang

CARO

Copyright © 1991 The Artist
Photography © 1991 John Riddy
Text © 1991 Karen Wilkin

First edition 1991
Published by
PRESTEL VERLAG
Mandlstrasse 26, D-8000 Munich 40, Germany
Tel: (89) 38 17 09 0; Fax: (89) 38 17 09 35

Produced for the publishers by
John Taylor Book Ventures
Hatfield, Herts

Designed by Kate Stephens

Made and printed in Great Britain by
CTD Printers Ltd, Twickenham, Middlesex

CIP-Titelaufnahme der Deutschen Bibliothek:

Wilkin, Karen:
Caro/Text by Karen Wilkin. Ed by Ian Barker. -l.ed.-
München : Prestel 1991
ISBN 3–7913–1137–9
NE: Caro, Anthony [Ill.]

Distributed in continental Europe by Prestel-Verlag
Verlegerdienst München GmbH & Co Kg
Gutenbergstrasse 1, D-8031 Gilching, Germany
Tel: (8105) 21 10; Fax: (8105) 55 20

Distributed in the USA and Canada by te Neues Publishing Company,
15 East 76th Street, New York, NY 10021, USA
Tel: (212) 288 0265; Fax: (212) 570 2373

Distributed in Japan by YOHAN-Western Publications Distribution
Agency, 14-9 Okubo 3-chome, Shinjuka-ku, J-Tokyo 169
Tel: (3) 208 0181; Fax: (3) 209 0288

Distributed in the United Kingdom, Ireland and all remaining
countries by Thames & Hudson Limited
30-40 Bloomsbury Street, London WC1B 3QP, England
Tel: (71) 636 5488; Fax: (71) 636 4799

ISBN 3–7913–1137–9